Fred Dervin • Xiaowen Tian

Critical and Reflective Intercultural Communication Education

Practising Interculturality Through Visual Art

Fred Dervin ⓘ
Faculty of Educational Sciences
University of Helsinki
Helsinki, Finland

Xiaowen Tian
Art Academy
Minzu University of China
Beijing, China

ISBN 978-3-031-40779-6 ISBN 978-3-031-40780-2 (eBook)
https://doi.org/10.1007/978-3-031-40780-2

Cover pattern © Melisa Hasan

This Palgrave Macmillan imprint is published by the registered company Springer Nature Switzerland AG.
The registered company address is: Gewerbestrasse 11, 6330 Cham, Switzerland

Paper in this product is recyclable.

ACKNOWLEDGEMENTS

The authors would like to thank the following artists for allowing them to include pictures of their artworks in this book: Ding Yunqiu (for Ding Tianque), Fu Aimin, Hu Changqiong, Wei Qi, Wuriqiefu and Xi Peng Cai.

ABOUT THE BOOK

Critical and Reflective Intercultural Communication Education: Practising Interculturality Through Visual Art provides answers to the following questions: *When we look at, engage with and experience art, what is it that we can learn, unlearn and relearn about interculturality? How could visual art support us in reflecting about interculturality critically?* This book adds to the multifaceted and multidisciplinary field of intercultural communication education by suggesting and urging those working on the notion of interculturality (researchers, scholars and students) to give art a place in exploring the complexities of the notion. No knowledge background about art (theory) is needed to work through the chapters. The book helps us reflect on ourselves and on our engagement with the world and with others, and we learn to ask questions about these elements. The authors draw on anthropology, linguistics, philosophy and sociology (amongst others) to enrich their discussions of art and interculturality.

CONTENTS

ABOUT THE AUTHORS

Fred Dervin is Professor of Multicultural Education at the University of Helsinki (Finland). Dervin also holds several distinguished and visiting professorships in Australia, Canada, China, Luxembourg, Malaysia and Sweden. He has widely published in different languages on identity, the 'intercultural' and mobility/migration (over 150 articles and 80 books). His latest books include *The Paradoxes of Interculturality* (2023) and *Interculturality in Fragments* (2022).

Xiaowen Tian is a researcher at the University of Helsinki (Finland) and a lecturer at the Art Academy of Minzu University of China. Tian's research focuses on Minzu art education and intercultural education. Inspired by Dervin's interculturality in education, she proposes to systematise and theorise Minzu art education through a critical and reflexive intercultural lens, taking into account the specificities of the Chinese context. Tian has published on Mongolian and Buddhist art and the notion of Zhongyong in relation to interculturality.

LIST OF FIGURES

The Power of Art?

Abstract The introduction justifies the needs and objectives for the book in relation to the broad field of intercultural communication education and research. It first reviews previous studies on art and interculturality in education and other fields and aims to make the reader reflect on their own take(s) on art and their (daily) experiences of it. In the next part of the introduction, the authors problematize the idea of interculturality. Different takes on the notion are discussed. The need to enrich our views on the notion is also emphasized. A fluid, transformative and interactional perspective is suggested in the book, focusing on the *inter-* and the *-ity* of the notion of interculturality, with each chapter allowing us to reflect on its characteristics. The introduction ends with a presentation of the chapters and a description of the book working principles.

Keywords Indian theatre • Interculturality • Art • Ideologies • Interdisciplinarity

F. Dervin, X. Tian, *Critical and Reflective Intercultural Communication Education*, https://doi.org/10.1007/978-3-031-40780-2_1

[THINKING FIT[1]]

1. Why do you want to read our book? What are your motivations? What are you expecting to get from it?
2. What do you think that we, the authors, learnt in the process of writing this book?
3. How would you define both *interculturality* and *(visual) art*? Are you aware of other ways of delimiting them? How different and similar are they from yours?
4. Try to review for yourself what you already know about interculturality (e.g. authors, 'models', theories, concepts, specific studies). How much have you read about (visual) art and interculturality? What topics and research results are you aware of?
5. Try to remember the latest art piece that you have observed, for example, in a magazine, online or at a gallery. How could this piece support you in reflecting on interculturality? What aspect(s) of interculturality could it help you consider from a (maybe) different perspective?

OPERATE SOME DISTANCING

We start this book with a short mind exercise to distance ourselves from our current location/mindset and from the re-presentations that we might have about what this book could be about.

Imagine that you are on the southern coast of India, in the state of Kerala, sitting in what could be described as a 'theatre'. You are about to watch/take part in a dance drama in the open (maybe a village square), beginning at sunset and lasting through the night. The stage is rather small, and there is no scenery, just an oil lamp spreading the 'light of knowledge' to both performers and the audience, placed in the middle of

[1] Each chapter opens with a list of questions to you, the reader, so that you can reflect on the content of the chapter [Thinking Fit]. As the authors, we are very aware of the diversity of multilingual and international readers who will open this book. Although the list might appear 'random' at times, it is meant to reflect the flow of interrogations that one faces in intercultural encounters. As will be argued in this book, interculturality does not go in a 'straight line'. It is a complex, often incoherent phenomenon that confuses us. We may not necessarily have one answer to these questions (or any answer at all!). Therefore, treat these questions as a time for taking a short break, thinking and imagining answers for yourself about the issues that interculturality pushes us to consider.

the stage. There are singers and musicians playing the drums, gong and the tamboura backstage and actor-dancers with and without make-up resembling masks, wearing skirts, jackets, necklaces and big headdresses, who mime the story. The actors use wide and strong gestures and facial expressions to act out a struggle between good and evil. The show is called *Kathakali* (katha = a story; kali = a dance) and is based on a 300-year-old form of ritual theatre, inspired by both religion and mythology. In order to understand this form of *total theatre* (acting, music, colours, costumes), one should be able to read the numerous 'signs' on the actors' bodies and faces (*mudras* in Sanskrit), which all have narrative functions. For example, to express terror, actors raise one eyebrow and then the other, open their eyes wide, move their eyeballs, make their cheeks tremble and revolve their head in jerky movements. Hands and fingers also follow a complex set of 'signs' and should accompany, for example, facial performances. Colour codes are also meaningful, for example, a red beard indicates evil characters, while a white one low-born characters who are holy. The storylines are simple, but the duration of a performance can take all night long. Usually the audience is well cognizant of the plot and is mostly interested in how the actors will be able to perform the ritual, to render different emotions and how much they can be startled by their acting. Barba (1967) notes the following fascinating aspects of *Kathakali*. Try to see how much they require distancing yourself from what you know of theatre if you were to watch such a play:

1. Before each character enters the stage, they are introduced slowly to the audience behind a veil so that they can become aware of the type of character about to perform. The process takes about 20 min per character.
2. During the show, the characters' mouths are shut, and they are only allowed to open them when they scream. Their eyes are 'hypermobile'. Barba (1967) tells us of a character in *Kathakali* who performs a butterfly burning itself in a flame by the movements of their eyes alone.
3. The actors' eyes should follow their hands, 'transforming' the latter into an imaginary object or person.
4. Distancing moments are essential in *Kathakali*. For example, in order to relax the spectators, each (dramatic) chanted verse is followed by a few minute-long dance interlude to give them time to think about what they have just heard and witnessed. Another

instance has to do with actors sitting on a stool on stage after, for example, a solo, touching up their make-up and rearranging their costume—going back to their identity of a real person, before re-emerging as a supernatural being when performing again.

Some of our readers might have witnessed *Kathakali* in India, but we assume that most of us have not. *How did you feel while reading about this form of ritual theatre? Would you like to experience it? What would you learn from and with it? What intellectual and emotional preparation would you need before watching Kathakali? What mind shifts might occur in you?*

Most of us will have been to some form of theatre and have precon-ceived ideas about how it takes place, what the actors are meant to do and not do, the role of music, settings and costumes (amongst others), what is a 'good' and 'not so good' performance, etc. A 'total theatre' like the one described here asks us to reconsider our *re*-presentations, beliefs and the ideological 'orders' (i.e. acceptable/unacceptable ideas and views) that have been passed onto us about what the theatre is and what it should 'do' to us.

Liberating Ourselves in Front of Interculturality

We both specialize in intercultural communication education. Fred, the author of this introduction, has contributed to global research on intercul-turality in different languages since the 2000s, and Xiaowen, the co-author of Chaps. 2, 3 and 4, has made some contribution to Chinese Minzu 'ethnic' art education, examining it through different Chinese and Western paradigms. Xiaowen has also graduated in fashion studies and lectured on different aspects of Chinese Minzu clothing in China. Fred is also an artist and has been actively involved in combining his research and art over the past five years. This is how he describes his double position as a scholar and an artist:

> I am above all an academic, someone who specializes in intercultural com-munication and education. I spend my days thinking and writing about the important topic of interculturality. I have been doing so for the past 20 years. When my writing day is over, I move to another part of my home and do some art. For me, both activities are complementary. What I cannot say in writing, I express through painting. What I cannot express in art, I write about. Sometimes, I am able to combine both research and art. (…) Working on intercultural encounters in both research and art, I wish to help others

unthink and rethink the ways they engage with people, objects and ideas from different parts of the world. I see interculturality as a necessary lifelong process of in-betweenness and co-construction.

This book asks the same from us as *Kathakali* does to theatre-goers, focusing on interculturality. It is a book of liberation from our own (often limited and limiting) ways of engaging with a notion that can take on many forms in different corners of the world and in different languages, although we tend to restrict it to a few globally dominating 'models', theories and ideologies (Atay et al., 2023). What our book says is that we need to re-imagine and re-interpret interculturality. More importantly, we wish to inspire you to let your mind float, focusing on the transitory, the fluid, the accidental—and at times the chaotic. Our point here is not to imprison you in a closed understanding of interculturality but to use art as a companion to approach the notion, the way we engage with it and others, in an open-ended and flexible manner. Our own thoughts on interculturality are always 'small' when compared to the richness and diversity of thoughts on it found around the world (Dervin & Jacobsson, 2022). While dominating takes on the notion, mostly from the Global North, give us the illusion that interculturality might mean and function in a single specific way (see, e.g. current models of intercultural competence in Peng et al., 2019), we must look into the wider network of perspectives on the notion, exploring their encounters, symbioses, but also their conflicting and violent relations in different corners of the world and in different languages (R'boul, 2022).

Interculturality here is not a synonym for *international*, but it goes deeper in exploring other forms of diverse encounters with others and around us. It is not about 'culture' (a somewhat empty signifier and a substitute of a concept that encompasses 'everything', see Wikan, 2002) but about the *inter-* and the *-ity* of the notion: in-betweenness and never-ending processes of encounters. Interculturality is itself *intercultural*—a polysemous and multifaceted notion used to make sense of our *self, others* and *the world*. It is an omnipresent phenomenon, qualifier and tool for which no one is (only) right or wrong but (both) right and wrong. Too often, we scholars and educators give lessons as to what interculturality should correspond to and how we should make use of it by retaining one single way of constructing the meanings of the notion (see Tan et al., 2022). Although there are often similarities in the way(s) we voice these elements, positioned linguistically in different ways (e.g. *we might say*

'*respect*' *in English, they might say* '*recognition*'), forms of centrism such as *ideologism* (the way we give 'orders' about how it should be spoken of and done) and *ethnocentrism* often fool us into believing that our conceptualization of interculturality is the only valid form of interculturality. We argue that it is a problematic illusion that must be put on the negotiation table as often as possible.

This book deals with reflecting on critical interculturality by practicing through art. Although the examples used in the book have to do only with visual art (painting), we use the generic term 'art' in the following chapters not to overcrowd the text linguistically and visually. We propose that art, which is also omnipresent in our lives (homes, museums, streets, schools) in different forms, is an original and rich source of reflections on interculturality. Like interculturality itself, art does not always require a theory about what is to be understood, and artists themselves do not always know how to discuss their artwork or are not willing to do so *in words*. '*What does your art represent?*' is a question that might be met with an artist answering: 'I don't know', 'it is not meant to represent anything' or 'you decide for yourself. Rely on your own interpretation'. According to Joseph Beuys (in Cavadini, 2013) *every man is an artist*: Anyone can create art and be an artist; anyone has creative abilities which they can use to influence and transform the world. Jean Dubuffet (in Aviral et al., 2016) called the form of art that he did *art brut*, meaning art expressed without any need for explaining what it is about.

Like interculturality, art itself is also a multifaceted form of encounters between the artist and their art, between the art and the viewer, between the viewers, within the artwork between different livings and non-livings, etc. As such art reflects the complexities, contradictions and instabilities, changes of social processes and by being open to us at all times, art can help us practice thinking about interculturality almost everywhere and all the time. For Picasso (in Berger, 1989: 54), for example, 'We all know that Art is not truth. Art is a lie that makes us realize truth at least the truth that is given us to understand. The artist must know the manner whereby to convince others of the truthfulness of his lies'. All in all, art can force us to accept the unplanned and the accidental; art can represent different forms of expression and interpretation; art can urge us to re-interpret the world for and with ourselves and others; art can support us in talking about ourselves, others and the world; art can lead us to intellectual, epistemic, mental and symbolic transformations. In that sense, art represents a good companion for reflecting on interculturality.

THIS BOOK IS NOT AN 'ART BOOK'

In the book we start from the argument that interculturality—and polyse-mic companion terms such as *multiculturality, transculturality* and *global-ity*—is central to research, education and the world today and that one cannot do away with it to prepare us to meet the challenges of today and of the future when meeting the *other*. As a complex and ideologically diverse notion, interculturality deserves to be treated itself 'intercultur-ally'. This means that we need to expand our understanding of the notion, listening to as many and varied voices engaging with it as possible. Our book adds to the multifaceted and multidisciplinary field of intercultural communication education by suggesting and urging those of us working on the notion of interculturality (researchers, scholars and students) and people experiencing it to make use of art in exploring some of the com-plexities of the notion. The focus is on developing criticality and reflexivity for interculturality through examining art as a tool to do so.

Art is understood in broad ways in the book, but most of our references concern painting of the twenty-first century, especially from China. Art is very complex around the world, and choosing specific art pieces to include was a real 'brainteaser'. We chose contemporary Chinese art (as well as a few pieces from one of the authors produced in the Chinese context) that the readers may not know to avoid too much intertextuality in the sense that choosing, for example, famous 'Western' art pieces, would impose specific *re*-presentations of the pieces and the artists behind them based on one's (potentially flawed) acquaintance with them. We note that many of the art pieces from China were done by diverse representatives of Chinese society, for example, members of different Chinese Minzu 'ethnic' groups. We do realize that painting is only one limited form of art, and we thus urge readers to be curious of and explore, for example, photography, sculpture, experimental digital art and performance art (artists such as Marina Abramovic, Xu Bing, Kehinde Wiley) [and even Hollywood cin-ema or pop culture] from different eras and different parts of the world. It is genuinely hoped that, beyond the limited scope of this book, the reader will find inspiration in other forms of art.

As paradoxically as it might sound, the book is not a book about art but a book about interculturality first and foremost and about the benefits (and potential drawbacks) one can get from looking at and experiencing art to reflect about the notion. As such no knowledge background about art (theory) is needed in order to read the book. It is our assumption that

too many people feel that they need to know about a piece of art that they see/experience and that not knowing about it refrains them from 'using' it to reflect on themselves, the world, their life experiences, others, the artist's intentions and the way(s) others engage with the piece. In some of the art examples that we will be using in the book, we might make references to the artists' biographies and personal experiences as complements for the reader. However, we do not expect readers to engage with such elements in systematic ways in exploring art for critical interculturality. Similarly, our book is not meant to support readers to evaluate what is *good/bad/tasteful/ugly* art. Through this book we want to liberate our readers from some of these limitations, insisting on the power of imagination in expanding our engagement with interculturality. Interculturality should be approached with and through imagination—not just necessarily through theories, ideologies and 'models' based on scholars', teachers' and decision-makers' own positions on *how to be* with each other. The art discussed in the book is *yours*. As Wilde maintained (2012: 41): 'It's the spectator, and not life, that art really mirrors'. For the French artist Garouste (2011), the work of art *belongs to* the viewer.

What we want to achieve with this book could be summarized as follows: *when we look at, engage and experience art, what is it that we can learn, unlearn and relearn about interculturality (*ad infinitum*)?* The book helps us reflect on ourselves, our engagement with the world and with others and learn to ask as many questions as we can about these elements—not always being able to provide answers. Art relates to the concept of imagination. Imagining the world—versus 'knowing' it—can enrich our engagement with its 'diverse diversities', a concept used by Fred (Dervin, 2016) to break down some of the problematic and ideologically limiting hierarchies between the imagined 'norm' (e.g. white people in Europe) and the imagined 'diverse' (e.g. some migrants, as referred to in Finland, Europe). Diversity is all around us; diversity is *in* us too. Finding several answers to our questions about interculturality is a necessity to avoid limiting our mis-perceptions and the labels that we create and impose on others (for instance, stereotypes, misrepresentations). With this book we argue that art can help us unthink and rethink both questions and answers provided by ourselves and others. Art can help us be reflective and critical of the ways we have been made to think about the notion of interculturality and of how we engage with it as an object of research and education. The focus here is thus on how art can support us

reflect, unthink and rethink thoughts, experiences, knowledges, world-views and (why not?) aesthetics of interculturality.

The book is interdisciplinary, and while drawing on different fields related to interculturality, it does make use of philosophy, anthropology, sociology and linguistics to help the reader reflect further on interculturality. Opening up the doors of different fields is a must for considering interculturality. Each chapter deals with central topics in interculturality: *identity, otherness, becoming, beliefs, ideologies* and *reflexivity*. It is aimed at anyone interested in interculturality, who want to reflect further on the notion. Multidisciplinary teachers, scholars, students and decision-makers will find it of interest to expand their views on what interculturality could mean and entail in global perspectives.

Some publications have problematized art and interculturality within the field of language education in recent years (e.g. Stratilaki-Klein, 2020; Khaled & Anderson, 2023). However, publications on intercultural communication education from the last few years have focused on, for example, *language, translation, migration mobility, tourism* and *digital technologies*, but not given art its due place in *thinking, unthinking* and *rethinking* interculturality as both a notion and a phenomenon. Although these publications all present fascinating ways of dealing with the notion, we feel that more could be done to open up our ways of engaging with interculturality from even more perspectives, especially from outside the field and from more parts of the world. With recent calls for enriching both research and education for interculturality (decolonial, post-human perspectives), we argue that art represents a rich and stimulating way to do so.

To our knowledge there is no other book published in English in the broad field of intercultural communication education that has tried to make use of art to enrich our take on interculturality the way we do—adopting a critical perspective *critical of itself* and pushing for approaching the notion differently *again and again*, building up some curiosity about other ways of exploring it. The following books can be considered as 'companions' on the general topic of interculturality rather than 'competition'. These books problematize the notion from critical, global and decolonial perspectives. Our book urges and guides readers to explore art for deepening their reflections on interculturality while adding and exploring critical and reflexive elements to the notion not covered in these books:

Aman. R. (2017). *Decolonising Intercultural Education: Colonial Differences, the Geopolitics of Knowledge, and inter-epistemic dialogue.* London: Routledge.

Asante, M. K., Miike, Y. & Yin, J. (2014). *The Global Intercultural Communication Reader.* New York: Routledge.

Dervin, F. & Jacobsson, A. (2022). *Intercultural Communication Education. Broken Realities and Rebellious Dreams.* London: Springer.

Dervin, Sude, Yuan, M. & Chen, N. (2022). *Interculturality Between East and West. Unthink, Dialogue, and Rethink.* London: Springer.

Ferri, G. (2018). *Intercultural Communication: Critical Approaches, Future Challenges.* London: Palgrave Macmillan.

Halualani, R. T. (2017). *Intercultural Communication: A Critical Perspective.* New York: Cognella Academic Publishing.

Holliday, A. & Amasi, S. (2020). *Making Sense of the Intercultural. Finding DeCentred Threads.* London: Routledge.

Ibelema, M. (2021). *Cultural Chauvinism: Intercultural Communication and the Politics of Superiority.* Routledge.

Piller, I. (2017) *Intercultural Communication: A Critical Introduction* (second edition). Edinburgh University Press.

While there are clear gaps in intercultural communication education, the international literature on various aspects of art has often dealt with issues of diversity, complexity and interculturality. As such, when one consults publications on art education, one notices that the intercultural is omnipresent although not directly mentioned or problematized. This is the case, for example, of Knutson et al.'s (2022) edited volume *Multidisciplinary Approaches to Art Learning and Creativity: Fostering Artistic Exploration in Formal and Informal Settings,* where interculturality is not stated but found in the arguments made and the examples used to illustrate key factors in facilitating creative processes when engaging in and through art.

In different fields attached to art (e.g. sociology of the arts, art history, comparative arts, aesthetics, art psychology/therapy), the notion of interculturality (and its companions) has been explicitly used. *The Routledge International Handbook of Intercultural Arts Research* (Burnard et al., 2016) represents such an example. It is described as 'providing concise and comprehensive reviews and overviews of the convergences and divergences of intercultural arts practice and theory, offering a consolidation of the breadth of scholarship, practices and the contemporary research

methodologies, methods and multi-disciplinary analyses that are emerging within this new field' (Burnard et al., 2016).

Publications on interculturality and art have dealt with:

1. **Aesthetics:** For example, Leuthold's (2010) *Cross-Cultural Issues in Art* introduces aesthetic concepts, beyond usual Western theorists and Western examples and discusses issues of colonialism, nationalism, religion.

2. **Art through the lens of (past and present) globalization:** For example, Elkins (2013) asks if art history is global. The issues of transcultural encounters and exchanges as artistic circulations have also been discussed (e.g. DaCosta Kaufmann et al., 2015; Durrer & Henze, 2020). In *China and the West: Reconsidering Chinese Reverse Glass Painting*, Ambrioso et al. (2022) examine the intensive cultural and artistic exchanges between China and the West based on the example of reverse glass painting.

3. **Mobility, migration, travel and art:** Their influence as transforming forces remodelling artistic practices. For example, transmedia aesthetics developed through travel (Li, 2022), the impact of migration on cultural policy and the performing arts towards a fair and accessible performing arts scene for all (Canyürek, 2022). In *French Women Orientalist Artists, 1861–1956: Cross-Cultural Contacts and Depictions of Difference*, Kelly (2021) intersects mobility and gender by focusing on 72 women artists' (labelled as French Orientalists) cross-cultural interactions with painted/sculpted representations of the Maghreb (Africa).

4. **Somewhat related to this topic, race, politics and art represent another focus in research on interculturality and art:** Pilic and Widerhold-Daryanavard (2021) look into the diversification of art today through critiques of discrimination and calls for inclusiveness. Ianniciello (2021) focuses on postcoloniality, migrations and art in the Mediterranean and proposes engaged art denouncing, for example, double standards in relation to refugees. Many such studies analyse the ways contradictions between (amongst others) multiculturalism and cultural hybridity and islamophobia and racism are depicted in art.

These topics will prove useful for this book, and we'll make some references to concepts, theories and examples from the publications referred to

here. Our book adds to this strand of the literature by (1) introducing a very specific perspective ('critical and reflexive interculturality' based on Dervin's long-term ongoing theoretical work, amongst others) and (2) placing art at the centre of reflexive work around interculturality in education, illustrating, deepening, opening up and moving to and fro in our exploration of interculturality.

WORKING WITH THE BOOK

This book is very special in the way it was written, making it somehow personable and dialogical. In writing it, we did not want to provide ready-made answers as to what interculturality is, 'does' and entails but to recommend a nuanced and reflective approach. This means that, at times, the book might contradict itself, revise some of its previous assertions, add further arguments and critiques, etc. This is done on purpose to reflect the ways interculturality as a concrete phenomenon occurs. As such the phenomena attached to the notion are neither straightforward nor coherent in reality; they are conflicting, inconsistent and confusing. We want you, the reader, to experience this also as you engage with the notion as a scientific construct in the book. This approach has to do with our reaction to problems identified in current scholarship about interculturality that hints at criticality towards the notion and yet tends to adopt, for example, overly 'Western' models of rationality, objectivity, one-directional perspectives. In other words, what we are doing in the book is adopting an approach to interculturality that aims to reflect some of the complexities of interculturality, instead of pretending that as writers, scholars and educators we can have full control of the notion. This might trigger some frustration in some readers. As much as interculturality can be an upsetting, annoying and difficult experience, we believe that dealing with it in, for example, research and education must follow similar patterns.

The book does not have the ambition to be comprehensive and wide-ranging. It aims instead to stimulate further thinking, research and education on the use of art as a reflective force for interculturality. Reading through the book does not necessitate following chapter after chapter. As such each chapter can be read independently. The conclusion offers a useful summary of the main takeaways and some questions for continuing to engage with art and interculturality.

Borges (1964: 213–214) argues that 'A book is more than a verbal structure or series of verbal structures; it is the dialogue it establishes with

its reader and the intonation it imposes upon his voice and the changing and durable images it leaves in his memory. A book is not an isolated being: it is a relationship, an axis of innumerable relationships'. This represents an important endeavour in writing the book. We want you, the reader, to feel comfortable about, for example, disagreeing with us and thinking further outside the framework of this book. Therefore, we have included questions (see the 'Thinking Fit' and 'Thinking Further' subsections) in all the chapters to help you continue reflecting on the topics. Lists of suggested reading are also found in the chapters.

The book is composed of five chapters, including an introduction and a conclusion. Each chapter revolves around an important question linked to interculturality and starts with a theoretical discussion of the most important concepts/notions one could use to examine the question. The chapters expose how art can help us reflect on these questions from intercultural perspectives. The chapters do not mean to offer definite or right/wrong answers. On the contrary, they urge each and every one of us to think further. The following concepts and notions are covered in the chapters: *identity, otherness, encounters, becoming, beliefs, ideologies* and *reflexivity*. Theoretically the book is anchored in Dervin's work on interculturality (e.g. Dervin, 2008, 2015, 2016, 2019, 2022), in long-term dialogue with other scholars (e.g. Dervin & Risager, 2017; Dervin & Auger, 2019; Dervin & Jacobsson, 2022; Dervin & R'boul, 2022), where these key concepts and notions have been reviewed, redefined and critiqued. In this book, interculturality is understood as encounters leading to (1) constant co-change and resistance between the people who meet, (2) (re-)negotiations of their identities, ideologies and beliefs and (3) power 'games'. In this perspective, multilingualism and a genuine interest in alternative 'non-Western' knowledges are promoted (e.g. Dervin & Jacobsson, 2022; Dervin & Tan, 2022).

Chapter 2 tackles the important and complex issue of identity, which has been described as central to interculturality—*inter-* and *-ity*—describing never-ending processes of in-betweenness and change (e.g. Machart et al., 2013; Dervin & Risager, 2017; Kaschula, 2021). As a mirror of multifaceted realities, art places identity at its centre too since it is through art that the artist describes (in/directly) themselves and the characters they portray (e.g. Roald & Lang, 2013). For instance, many migrant artists portray how they see their place (or others') in a given society, condemning, for example, injustice and discrimination. We could argue that a piece of art will also make people reflect on how they communicate with

others, helping them to go back to what they have 'done' and 'said' to others, accepting (or not) how they did it and/or making them want to change. This second chapter supports the reader in using art as a mirror for considering and unthinking their own identity as they see, are made to see or forced to perform it, while developing strategies to use art as a way of fluidifying the way they see themselves in relation to interculturality.

Chapter 3 focuses on the topic of encountering, problematized through the addition of the prefixes *re-* and *mis-* (re-encountering, mis-encountering). After problematizing the notion of intercultural encounters, we explicate why intercultural encounters should always been seen through the lens of dialogism—considering them as encounters that contain traces of other encounters (*re-*). Four concepts are then introduced to reinforce our understanding of re-encountering: *Face, mask, mirror* and *language*. These allow us to engage with re-encountering in more dynamic and multifaceted ways with self and other in intercultural situations. Finally, three art pieces are examined to illustrate the need to deepen our takes on meeting others.

After reflecting on identity and (re-)encountering, Chap. 4 takes us through unthinking and rethinking how we meet interculturally. It aims to equip us with critical and reflexive ideas to move away and beyond some of the limited and limiting takes that we have been fed with through, for example, our economic-political locations, education, research, the media and previous encounters. The postcolonial/decolonial and the more than human are problematized and discussed as examples to help us decentre some of our takes on the notion. Intercultural philosophy is also introduced. All in all, the chapter calls for us to endeavour discovering and trying out new perspectives on interculturality *lifelong*. At the end of the chapter art pieces are used to reinforce our awareness of the need to unthink and rethink *again and again*.

The conclusion, written by Fred, summarizes what to take away from the entire book, emphasizing the help art can provide for preparing us to reflect on interculturality in in-/formal contexts of education. The concepts and notions covered in the book, i.e. *identity, otherness, becoming, beliefs, ideologies* and *reflexivity*, are reviewed and problematized as a whole for art and interculturality. A framework concerning the role that art can play for interculturality in education is proposed to conclude the book and to summarize the transformative power of art for the notion. Finally, the conclusion suggests that more can easily be done to systematize the inclusion of art in intercultural communication education.

For the French philosopher Henri Bergson, artists 'see better than others, because they see the naked reality without any filter' (our translation of 'l'artiste, c'est un homme qui voit mieux que les autres, car il voit la réalité nue et sans voile', see Atkinson, 2020: 23). Although being 'filter-free' is virtually impossible in any aspect of our lives, one could argue that art can be produced, admired and observed in ways that are more fluid and flexible than, for example, research and/or education. We hope that this book will help you, the reader, open your eyes, ears and other senses to the super-complexities of experiencing, observing, understanding and making sense of a central notion of our (difficult) times: *interculturality*.

[THINKING FURTHER]

1. After reading the introduction, reflect on what you think you will learn with this book.
2. Summarize for yourself the connections and similarities between art and interculturality. Why would art be beneficial for reflecting on interculturality based on these elements?
3. Flick through the art pieces that we use in the next three chapters and reflect on how they might relate to what we have discussed in this introduction. If one of these pieces retains your attention, try to consider it through the lenses of identity, encountering and unthinking-rethinking interculturality. What does this piece tell you about these topics?
4. Before you start reading the following chapters (in the order of your choice!), try to delimit the notion of interculturality for yourself: what does it include/exclude? Who does it concern? What values do you consider important to be able to 'do' it? How are we supposed to 'do' it? What are the most important keywords for you to problematize interculturality? Now try to consider the points you made using completely opposite arguments, imagining how a person from another 'corner' of the world might answer these questions.

REFERENCES

Ambrosio, E., Giese, F., Martimyanova, E. & Thomsen, H. B. (2022). China and the West. Reconsidering Chinese Reverse Glass Painting. De Gruyter.

Atay, A., Eguchi, S., & Pindi, G. N. (Eds.). (2023). *Transnationalizing Critical Intercultural Communication: Legacy, Relevance, and Future*. Peter Lang.

Atkinson, P. (2020). *Henri Bergson and Visual Culture: A Philosophy for a New Aesthetic*. Bloomsbury.

Aviral, A., Minturn, K., & Rosenthal, M. (2016). *Jean Dubuffet: Anticultural Positions*. Rizzoli International Publications.

Barba, E. (1967). The Kathalaki Theatre. *The Tulane Drama Review, 11*(4), 37–50.

Berger, J. (1989). *The Success and Failure of Picasso*. Vintage International.

Borges, J. B. (1964). *Labyrinths. Selected Stories and Other Writings*. New Directions Press.

Burnard, P., Mackinlay, E., & Powell, K. (Eds.). (2016). *The Routledge International Handbook of Intercultural Arts Research*. Routledge.

Canyürek, Ö. (2022). *Cultural Diversity in Motion: Rethinking Cultural Policy and Performing Arts in an Intercultural Society*. Transcript Verlag.

Cavadini, N. O. (2013). *Joseph Beuys: Every Man is an Artist*. Silvana Editoriale.

DaCosta Kaufmann, T., Dossin, C., & Joyeux-Prunel, B. (Eds.). (2015). *Circulations in the Global History of Art*. Ashgate.

Dervin, F. (2008). *Métamorphoses identitaires en situation de mobilité*. Humanoria.

Dervin, F. (2015). Towards post-intercultural teacher education: Analysing 'extreme' intercultural dialogue to reconstruct interculturality. *European Journal of Teacher Education, 38*(1), 71–86.

Dervin, F. (2016). *Interculturality in Education*. Palgrave Macmillan.

Dervin, F. (2019). *Critical Interculturality*. Cambridge Scholars.

Dervin, F., & Auger, N. (Eds.) (2019). Les nouvelles voix/voies de l'interculturel. *Le langage et l'homme 1*. Special Issue.

Dervin, F., & Jacobsson, A. (2022). *Intercultural Communication Education. Broken Realities and Rebellious Dreams*. Springer.

Dervin, F., & R'boul, H. (2022). *Through the Looking-glass of Interculturality: Auto-critiques*. Springer.

Dervin, F., & Risager, K. (2017). *Researching Identity and Interculturality*. Routledge.

Dervin, F., & Tan, H. (2022). *Supercriticality and Interculturality*. Springer.

Dervin, S., Yuan, M., & Chen, N. (2022). *Interculturality Between East and West. Unthink, Dialogue, and Rethink*. Springer.

Durrer, V., & Henze, R. (Eds.). (2020). *Managing Culture: Reflecting on Exchange in Global Times*. Palgrave Macmillan.

Elkins, J. (2013). *Is Art Theory Global?* Routledge.

Garouste, G. (2011). *L'intranquille – version luxe: Autoportrait d'un fils, d'un peintre, d'un fou*. Iconoclaste.

Ianniciello, C. (2021). *Migrations, Arts and Postcoloniality in the Mediterranean*. Routledge.

Kaschula, R. H. (2021). *Languages, Identities and Intercultural Communication in South Africa and Beyond*. Routledge.

Kelly, M. (2021). *French Women Orientalist Artists, 1861–1956: Cross-Cultural Contacts and Depictions of Difference*. Routledge.

Khaled, F., & Anderson, J. (2023). Textart, Identity and the Creative Process: A Case Study with Arabic Heritage Language Learners. *International Journal of Bilingual Education and Bilingualism*. https://doi.org/10.1080/1367005 0.2022.2158721

Knutson, K., Okada, T., & Crowley, K. (Eds.). (2022). *Multidisciplinary Approaches to Art Learning and Creativity: Fostering Artistic Exploration in Formal and Informal Settings*. Routledge.

Leuthold, S. (2010). *Cross-cultural Issues in Art*. Routledge.

Li, S. (2022). *Travel, Translation and Transmedia Aesthetics: Franco-Chinese Literature and Visual Arts in a Global Age*. Palgrave Macmillan.

Machart, R., Lim, C. B., Lim, S. N., & Yamato, E. (Eds.). (2013). *Intersecting Identities and Interculturality: Discourse and Practice*. Cambridge Scholars.

Peng, R. Z., Zhu, C. G., & Wu, W. P. (2019). Visualizing the Knowledge Domain of Intercultural Competence Research: A Bibliometric Analysis. *International Journal of Intercultural Relations, 74*, 58–68.

Pilic, I., & Widerhold-Daryanavard, A. (2021). *Art Practices in the Migration Society*. Transcript Verlag.

R'boul, H. (2022). Postcolonial Interventions in Intercultural Communication Knowledge: Meta-intercultural Ontologies, Decolonial Knowledges and Epistemological Polylogue. *Journal of International and Intercultural Communication, 15*(1), 75–93.

Roald, T., & Lang, J. (2013). *Art and Identity: Essays on the Aesthetic Creation of Mind*. Rodopi.

Stratilaki-Klein. (2020). Articulating Arts and Intercultural Education: Static and Dynamic Views of Language Teaching at School. *Language and Intercultural Communication, 20*(4), 325–339.

Tan, H. Y., Zhao, K., & Dervin, F. (2022). Experiences of and Preparedness for Intercultural Teacherhood in Higher Education: Non-specialist English Teachers' Positioning, Agency and Sense of Legitimacy in China. *Language and Intercultural Communication, 22*(1), 68–84.

Wikan, U. (2002). *Generous Betrayal*. Chicago University Press.

Wilde, O. (2012). *Miscellaneous Aphorisms*. Start Classics.

Reflecting on Identity Metamorphoses

Abstract This chapter tackles the important and complex issue of identity, which has been described as central to interculturality—*inter-* and *-ity*—describing never-ending processes of in-betweenness and change. The notion of identity metamorphoses (from Greek for *change + form*) is used to problematize the unstable, shifting and negotiated characteristics of identity. The authors make use of a Chinese Confucian concept, *Zhongyong*, to support the reader in considering identity as a flexible and liquid object in intercultural encounters. Two art pieces highlight three levels of identity metamorphoses to reflect on oneself and others. This chapter supports the reader in using art as a mirror for considering and unthinking their own identity as they see, are made to see or forced to perform it, while developing strategies to use art as a way of fluidifying the way they see themselves in relation to interculturality.

Keywords Identity • Other • Change • Subjectivity • Identification

© The Author(s), under exclusive license to Springer Nature
Switzerland AG 2023
F. Dervin, X. Tian, *Critical and Reflective Intercultural Communication Education*,
https://doi.org/10.1007/978-3-031-40780-2_2

[Thinking Fit]

1. Is *identity* a word that you often use? With whom and for what purposes? How do you see the idea of identity? Is it something that remains the same, changes, stagnates and transforms at the same time?
2. What was the last art piece that you saw? How much of yourself (of your own identities) did you see in it? How about others (people close to you, groups of people)? Did the art piece help you reflect on who they are *with* and *for* you and how you *become* together?
3. One could argue that art is some sort of a mirror for the viewer—a mirror that tells them *this is you; this is not you; I represent who I think your people are* and so on. Art can also bring different kinds of feelings in us that might change our moods, feelings, ideas and conversations. Can you think of art pieces that have led to metamorphoses (from Greek for *change* + *form*) in you, in the way you see yourself, others, the world and life while looking into their mirrors?
4. As asserted in Chap. 1, through its power to imagine and *re*-present, art is in itself fluid like interculturality. Before reading the chapter try to speculate on the potential links between identity, art and interculturality. Do you believe that art can support us in enriching our take on the enmeshment of identity and interculturality? Why (not) and how?

From Sameness to Metamorphoses

A whole book could be written about a single person as he really is. Even that would not exhaust him, and one would never come to the end of him. But if you examine what you think of a person, how you conjure him up, how you keep him in your memory, you arrive at a much simpler picture: there are just a few qualities that make him noticeable and distinguish him from others. One tends to exaggerate these qualities at the expense of the others, and as soon as one has named them, they play a decisive part in one's memory of that person. They are what has impressed itself most deeply; they are the character. (Canetti, 1989: 14)

[*Metamorphosis*. 'From meta, here indicating "change" (see meta-) + morphē "shape, form" ' (etymonline, 2022). Change is at the heart of who we are, alone and/or together with others, at a distance, in close proximity, in absentia. Metamorphoses symbolize the multifaceted hyphens between our different *Is*; between us, us and them, us and it; between the past, present, future; between here and there.]

As asserted in Chap. 1, art places identity at its centre (e.g. Roald & Lang, 2013). Art also portrays us the viewers, without our consent, without our (full) awareness; it asks us to look at ourselves in its mirror. A work of art will also make people reflect on how they communicate with others and change together. *Art can please us, disgust us, talk to us, ignore us, trigger discussions between us. Art can tell us that we are good/bad people, beautiful/ ugly people, interesting/tedious people. Art can tell us that we are right and/or wrong. Art can make us dream, imagine, open our eyes in front of the complexities of the world. Art can make us accept that our realities are not the only reality. Art can make us ask questions but does not necessarily (wish to) provide answers.* [Can art 'do' any of these or do we 'do' them in its name?]

This chapter tackles the important and complex issue of identity. Levi-Strauss (1977: 331) points out that any use of identity should be critical of the concept before engaging with it. Let's start with some basic archaeological work: *identity* in English comes from Latin for 'the same' and 'sameness', based on a Proto-Indo European stem for the third person pronoun (found in Sanskrit too). This represents some kind of paradox for today's understanding of identity since it is often problematized as being 'liquid', 'fluid', 'changing' and 'renegotiated *ad infinitum*' (Maffesoli, 1997). The *Cambridge Dictionary* (2022) defines identity in a way that seems to crystallize identity too: 'who a person is, or the qualities of a person or group that make them different from others'. *Who a person is, qualities* and the emphasis on *difference* seem to leave little space for metamorphoses.

A lot has been written on identity in relation to interculturality over the past decades, and it has somehow taken over concepts such as *culture*—or at least become an inseparable companion (Dervin, 2016; Bauman, 2004; Sen, 2006). Its popularity in other fields of research such as psychology, sociology and anthropology has also influenced interculturalists to problematize and critique the concept.

Let us have a look at the word in the Chinese language (simplified written Chinese)[1] to see how multilingual discussions can add to our (un-/

[1] In the chapters we include references to the meanings and connotations of some words as often as possible. We believe that this plays a central role in problematizing any aspect of interculturality. Language is central to the notion, and we have been critical of how it is systematically ignored when scholars write in English. By pushing you, the readers, to see and consider other languages in the book, we wish to remind us all that interculturality is about *depaysement*, about being shaken and asked to step outside our own ideological, representational and linguistic world(s).

re-)thinking of the concept of identity. First, we note that, like many other contemporary concepts such as *culture*, Chinese scholars have translated and borrowed the word *identity* from 'Western' (sociological) research (Hai, 2018; Zhao, 2015; Fan, 2018). Second, identity can translate in different ways in Chinese. For example:

1. 身份 (character-per-character translation: *body-portion*) has to do with family background and social position.
2. 同一性 (character-per-character translation: *same-one-of*) refers to multiple objects of the same nature that can co-exist.
3. 认同 (*recognize-same*) represents a sense of identification, belonging and togetherness.
4. Combining some of these words, 身份认同 refers to personal identification, belonging and togetherness within a specific social context.

In Chinese identity often has to do with others, with belonging to a group and collectivities (compare with the aforementioned definition from the *Cambridge Dictionary* where the focus was mostly on *a single person* and *difference*). Others give us meanings; others contribute to and make our identities; others become us, and we become them. As we were writing this book, Xiaowen was expecting her first child and experiencing being identified as a 'mother'—with all her other identities being negated by most of the people she met. Although she could feel and bond with her baby 'inside of her' all the time, she knew that its identity was 'ignored' by others and that her identity as *a mother* replaced its own being. The baby had *no identity* for others, while Xiaowen had *a new identity* for them. For her, the baby had a concrete, real identity that was very much alive. Because identity is contextual, related to in-/visible togetherness, the way it is perceived depends on one's position in relation to others, place, time and so on.

It is important to note at this stage that identity is often limited and influenced by politics, economic status, social class, perceptions of nationality, culture and so on—which all impose some form of stability on us. Our own identity documents solidify who we are in front of others. They tell them how old we are (in terms of years), our height (maybe in metres and centimetres or in inches and feet), our (official) names (with some of us having neither surnames nor first names) and sometimes even the

colour of our eyes (black, brown, blue but nothing in between these colours, as if eye colour was unambiguous). However, these do not reflect the real complexities of our identity—the inner dialogues and changes that we experience constantly. They do not reflect the power struggles that we face with others when they impose identities on us and refuse to listen to the way we identify. Fred has often made a reference to one of the most traumatic moments of his life and career as an example of such struggles. Many years ago, in Italy, he was meeting with colleagues from different parts of Europe for a project on intercultural preparation in higher education (which was later 'sold' to the Chinese through another EU project). The atmosphere was rather pleasant until one of the 'local' project members, obviously obsessed by (their own) issues of 'solid' identities, started questioning him *police-like: where are you (really) from, Fred?* Having listened to him speaking English for a while, they interrupted his conversation to inquire about his origins. *Fred, where are you (really) from?* [this 'normal' and yet painful question of identity in interculturality]. Fred refused (politely) to answer once, and then twice and then many times. After a while, Fred felt too frustrated to allow this 'identity police inquiry' to continue and 'revealed' one dark side of his 'origins' provocatively. *Silence around the table. No one spoke.* Very upset about this unforgivable experience, Fred wrote in his diary, imagining that he could have addressed this person:

> Next time you submit someone to this kind of 'inquisition', remember that life, family history and 'origins' are not always as rosy as you might think. I could be polite and lie about who I am, turning myself into some kind of superhero of interculturality, with a glorious list of identities, leaving the darkness behind. The question you are asking me insistently (and clumsily) is in fact a disturbing one. You feel you have the right to ask me this question, that you have the power to do so. I am a white European man, so I am considered as 'privileged' – and in many ways I am. However, *behind everyone's identity, there is a complex network of present, past and future voices. Behind everyone's identity, there is always pain, 'successful' and 'failed' relations, secrets and lies, some form of trauma. Behind everyone's identity, there is always much more than your eyes, ears and other senses could ever meet... Behind everyone's identity, there is always change.* If you ask someone "where are you (really) from?", you need to accept that they don't have to reply and stop insisting. If they do wish to respond, you must accept and respect the fact that they might want to change 'forms' *with* and *in front of* you; you

must also take the responsibility for the pain you might inflict on them (*and vice versa*).[2]

For Bauman (2004: 19): 'asking 'who you are' makes sense to you only once you believe that you can be someone other than you are; only if you have a choice, and only if it depends on you what you choose'. Canetti (2021: 46) urges us not to inquire about identity: 'Don't tell me who you are. I want to worship you'. What the writer means is that 'declining one's identities' destroys the pleasure of meeting the other as a mystery, as a complex 'becoming' (instead of 'being') and as someone to worship. This will be a ritornello in this book: we don't need to (wish to) know who the other is; we can meet beyond knowing. *Worshipping the other in all their unknown embodies an exciting objective for interculturality.*

[Lesson number 1 for identity metamorphoses and interculturality. The only interesting questions about identity are: *Who do we think we become together with others? Who do we allow ourselves and others to become?*]

Making Sense of Identity *with* Interculturality

It is the 'crisis of belonging' (Bauman, 2004: 20)—or noticing that the other (and even ourselves) lacks 'clues' as to who they are becoming with(out) others (see the question of *Where are you (really) from?*)—that makes us reflect, question and critique identity. As such one often talks of *identity politics* today. Identity work is always political.

Politics brings to mind the problematique of *power*, which is an omnipresent issue in identity *with* interculturality. The very word *interculturality* relates in many ways to power.

Inter- is about how we work together in trying to achieve something: *living together and working together* but also *negotiating together, struggling together, becoming together and feeling together*. *Inter-* indicates systematic power differentials and struggles, from which we cannot escape, even when we think that what we do and say together has nothing to do with power. *We always pull and push together in all directions, to and fro.* At

[2] As we were finishing this book, international media reported that an honorary member of the British royal household resigned after asking a charity CEO the following questions: "where do you really come from?", "where do your people come from?" and "when did you first come here?". Interestingly, one of the reviewers for this book made the following remark after commenting on the fact that, according to them, we had 'failed' to specify that we were speaking about Mandarin instead of Chinese in this book: 'Isn't one of the authors Chinese?'.

times we agree, and at other times we fight. At times we don't care; we 'fake it'. We stereotype each other loudly and/or silently. We utter things that we believe are clever, harmless, nice, but which are perceived differently by others. Things can also change quickly when we meet others: *at moment X, I 'win', at moment Y, you 'beat' me* (at very few moments, we don't compete). *Inter-* is not a 'rosy' 'happy' set of relations that makes us successful at being/becoming together. Any act of *inter-* is an act of 'powering' together, pushing and pulling power symbols, concrete power differentials and so on. *Identity* plays a central role in this lifelong and never-ending process. The way we identify with and for each other, the way we are identified for and with each other and the way identities precede who we are (becoming) together are enmeshed in endless processes of pulling-pushing together in all directions, to and fro. Doing interculturality is opening the pandora box of human complexities, unexpectedness, injustice, evils and goods.

[*Pause:* Two idioms from Chinese remind us of important aspects of the *inter-* and identity: *disguise* and *power reversals*.

1. 乔装打扮 translates as 'to change one's dress and make oneself look different', 'to disguise one's true identity in order to deceive others'; 装 means *to pretend, to feign.*
2. 贵贱无常 translates as *aristocracy is impermanent* and refers to the fact that 'the status of people is not eternal'. The literal meaning is that one's identity as 'rich (贵)' or 'cheap (贱)' is constantly changing.]

[Philosophers of yesterday and today can also inspire us in thinking further about who we are/become alone and together with others. The philosopher of change, Henri Bergson (1859–1941), urges us to place change at the centre of our reflections on self, other, life and the world. Another philosopher, Byung-Chul Han (2020), stresses that as humans we *always* relate to others; we cannot ignore that essential part of who we are; banishing the *inter-* from our lives corresponds to putting an end to our very existence.]

Let us take another short detour via Chinese thought to problematize the *inter-* further and the central issue of power relations in identity-making. We make use of the concept of zhongyong (中庸, zhōng yōng), which we define as 'a constant (inner) appeal to (counter-)balance power between self and other and to trigger and negotiate potential change in them, while retaining one's right for difference' (Tian & Dervin, 2022).

Zhongyong has been presented as one of the central themes of Confucian thought, and in the twelfth century CE, a book of the same name was republished together with three other canonical texts of Confucianism (e.g. *The Analects* of Confucius, 论语 lún yǔ) and served as official subject matter for civil servant examinations in China. Zhongyong is an untranslatable (Cassin, 2016), which means that it has to be translated again and again—but not that it cannot be translated. Often, it is translated as *centre, unchangeable, Doctrine of the Mean* and *The Golden Mean. Equilibrium, honesty, lack of prejudice, moderation, objectivity, propriety, rectitude, sincerity* and *truthfulness* could also serve as equivalents in the English language. In these translations one can feel the idea of people balancing, centring when they interact with each other and be(come) together. If one decomposes the word itself, one finds Zhong (中, zhōng or zhòng), which can mean *middle, mean, central* and *being moderate in one's words and deeds,* and Yong (庸, yōng) referring to *common, ordinary, unchanging* and in some cases *inferior. Key Concepts in Chinese Thought and Culture* (2022, n.p.) provides the following explanation for acting in a Zhongyong manner: 'a friend should be neither too close nor too remote. Neither in grief nor in joy should one be excessive, for unregulated happiness can be as harmful as uncontrolled sorrow. Ideally, one must adhere unswervingly to the mean, or centre course, at all times and in every situation'. In Tian and Dervin (2022), we problematized Zhongyong for interculturality following these principles:

1. Self-awareness is central in Zhongyong. Therefore, considering the consequences of one's actions on others and situations—trying to see things from others' perspectives, trying to identify *with* them, beyond a mere focus on self—is a first step in unthinking and rethinking interculturality.
2. Listening carefully to, examining the language that self and other use to talk about and to each other and balancing/recalibrating what we say and do with words are vital. Language is one of the main entries into identifying for and with others.
3. Focusing on harmony in diversity, finding similarities in differences and differences in similarities correspond to other important steps in applying Zhongyong to what we do interculturally. Harmony, differences and similarities all have to do with the way we do, express, *re*-present who we are as individuals and as (non-)members of groups. The necessary tensions of differences and similarities in the

way we identify force us to perform endless but stimulating balancing acts, at times, allowing us to get closer to the other. It is through such acts that change takes place interculturally.

The *inter-* of interculturality is one of the most challenging aspects of the triad of (1) inter- (2) cultur- (3) -ity since it is unpredictable, (often) irrational, attached to multiple and contradictory identity projections, fantasies, ideologies, agendas and needs and requires constant work between those doing interculturality. No one can claim that they can 'do' the *inter-* perfectly or in 'controlled' ways. Any intercultural encounter must be done and experienced as if it were always a 'first time'. Zhongyong reminds us of the need to balance, recalibrate and, thus, remind ourselves of our and others' power statuses and struggles. The enmeshment with the other is well expressed by another Chinese idiom: 我中有你，你中有我—*I'm inside of you and you inside of me*; *my self is your self and* vice versa.

Following the *inter-* another component of the triad is *cultur-*. As the reader will have realized, we have neither used nor discussed the concept of culture in the book until now. Although it is often said to be one of the basic elements to indicate identity *interculturally* (e.g. Halualani, 2017: 122), what culture is and refers to concretely for different people in different languages and socio-economic contexts is a bone of contention. For a long time, *culture* referred to national cultures in relation to interculturality. For a long time, culture was a substitute for *individuals*, turning them into automata but also other constructs that one was not allowed to use in specific contexts such as *race*. For a long time, culture was misused and abused as a powerful 'Western' tool to classify people into 'good', 'bad', 'superior', 'inferior', 'politer' and 'less polite' (and all kinds of other problematic comparatives, see Baumann, 1995). For a long time, culture served as a way of establishing and imposing one's power on others (see ethnocentrism but also conceptualism, whereby one uses specific concepts as the only explanations for what people do and say). Today, although the word is still very much present in research and education, it has taken on a 'softer' role, either referring to small vs. large cultures (Holliday, 1999) or as a 'liquid' concept serving as a counterpoint to essentialism. In many cases, culture in the triad is (still) too broad to make any concrete contribution to critical discussions of identity and interculturality. Fred used to hear people tell him 'Don't throw the baby with the bathwater', when he claimed to be doing *interculturality without culture* in the 2010s (Dervin, 2016). Today, culture seems to be increasingly left to fall in a state of

disuse, 'ghosting' research and education (Dervin & R'boul, 2022). So what to do with the *cultur-* of the triad? We believe that it is important to open it up and to try to name it as it is (Wikan, 2002). Sometimes it is about money (e.g. competing for financial recognition) and other times about gender differences and (mis-)perceptions. Sometimes it is about religious beliefs/superstitions and other times taste (e.g. rap music). Sometimes it is about a series of phenomena that intersect: professional occupation, 'ethnicity', age difference, hobbies and so on. Naming is always problematic because we might mislead self and others in understanding what it is that we are analysing. However, naming here should be fluid, opened to constant change, to renegotiations of meanings and to discarding certain labels. As much as *the inter-* requires Zhongyong (balancing otherness with otherness, confronting identities), *cultur-* urges us to look for and engage in meaningful discussions between us around what it is that we are doing and 'discoursing' together, digging into the unsaid and the silenced.

[The question of 'what is culture?' is not an issue for the 2020s, especially not for *inter-cultur-ality*. Too much energy has been spent on this question since the emergence of 'Western' modernity (Wikan, 2002), often to confirm someone's superiority and to look down on the other. Instead, we might want to consider questions such as:

1. 'Why are we (asked to be) together?'
2. 'Why do researchers, educators and decision-makers have such expectations about what we should do and say together?'
3. 'What is the point of interacting then?'
4. 'What is it that we want from each other?'
5. 'How could we meet each other in more "authentic" ways?'
6. 'What ready-made networks of explaining and understanding what we are (supposed to be) doing together do we need to undo and redo together?'
7. 'What economic and political issues do we need to put on the table so we can start speaking to each other?'

The (often clumsy and faulty) answers provided to the question of 'what is culture?' always represent a limited and limiting range of viewpoints about self, other and the world, which may pass as 'scientific' but are in fact ideological (Holliday, 2011).

Identity (and thus interculturality) is expunged whenever culture is congealed. Metamorphosis then turns into stagnation.] The last element of the interculturality triad is *-ity*—a suffix that also indicates endless transformations. As hinted at for the other aspects of the triad, we are never really the same with other people; we adapt to characters, situations and contexts. We also change with time and space. Who we are depends on what we do and say with others. In the process of communicating with others, we influence each other, *for better or worse* [change is not always a good thing.].

There is now some awareness in intercultural education and research that the -ity of interculturality is an important aspect. As much as we know that culture is not *this or that*, but this *and* that, -ity reminds us that there is no perfection when it comes to interculturality. Sometimes we might be doing it well and other times not so well. At times we might not even realize that we are doing *anything*. Interculturality is life; it is ongoing, it does not start, and it does not stop. It is there with us all the time—even when we think that we are not embedded in it. Scholars (and many educators) are now fighting against *stereotypes, essentialism, culturalism, racism* and so on in their engagement with interculturality in education (see, e.g. Ghaffour, 2022). As a complex ensemble of processes, encounters, ideologies, economic-political agendas, power-laden relations, knowledge production and dissemination (amongst others), interculturality cannot be an 'escape proof net' for such 'evils'. There is a need to recognize our infallibility and to think about interculturality long(er) term rather than as a range of 'interims'. One specific encounter is only a small piece of a lifelong jigsaw that will witness 'successes' and 'failures'. Identity metamorphoses remind us of these important aspects of interculturality.

Before we move on to exploring these ideas by means of two art pieces, let's summarize the points made hitherto about identity metamorphosis and interculturality:

> *Inter-cultur-ality is about us; you, me, them and it (the non-living); the hyphen between us.*
> *It is about us allowing ourselves to become together.*
> *It is about us metamorphosing together, morphing into each other and separating each other.*
> *It is about us understanding who we become together.*
> *It is about us balancing otherness with otherness.*
> *It is about us negotiating and creating together, pushing aside our privileges and becoming aware of them.*

It is about giving (changing) meanings to our encounters.
It is about us confronting our silences and multiple voices.
It is about us discovering other realities.
It is about us confronting conceptual ghosts and carnivores that blind us in front of self, other and the world.
It is about us questioning our thinking together.
Finally, it is about accepting failure too.

REFLECTING ON IDENTITY METAMORPHOSES THROUGH AND WITH ART

Whoever wants to know something about me, they should look attentively at my pictures and there seek to recognize what I am and what I want. (Klimt in Troisi, 2017: 28)

In this section we focus on two art works to continue exploring and reflecting on identity metamorphoses for interculturality. The two pieces were produced by Chinese artists (one from the Mongolian Chinese Minzu 'minority' group, the other from the Han Minzu 'majority' group—as a reminder: Mainland China has 56 different Minzu 'ethnic' groups including one 'majority' group of Han people). These two pieces depict their own ways of constructing different aspects of identity, both collective and individual and both referring to elements from nature (a pomegranate, a wolf, grassland). Piece number 1 is entitled *Minzu Unity* (民族团结, 2021) by Wei Qi (Fig. 2.1) and *White Wolf with Mother Earth* (苍狼与大地) by Wuriqiefu (Fig. 2.2). Before we start discussing the artworks one by one, let's reflect on the following questions:

1. Spend a couple of minutes looking at the two pieces. What connections to identity metamorphoses and inter-cultur-ality do you see in them? What potential transformations are taking place?
2. What symbols seem to stand out in relation to China, politics, identity and community?
3. How do you imagine each art piece to be in terms of size[3]? What kind of material(s) did the artists use to produce them and for what potential purposes and effects?

[3] We note that we ask the reader to 'imagine' here. As in many of the questions that we ask in this book, we leave the space to readers to imagine for themselves away from the idea of finding 'the' and/or one 'truth'.

Fig. 2.1 *Minzu Unity* (2021, Wei Qi)

4. Consider the titles of the art pieces (*Minzu Unity* and *White Wolf with Mother Earth*). Looking at the pieces, what could these titles mean? What are they telling the viewers? What do the colours, characters and shapes have to do with the messages of the titles? What do you expect the art to say about the artist too?

Let us start with Wei Qi's *Minzu Unity* (民族团结, 2021).

Basic information about the piece: The size of *Unity Minzu* is 90 × 90 cm, and the technique used for this piece is woodblock (printing). Wei Qi is a lecturer in arts at Minzu University of China in Beijing, who specializes in oil painting. The artist uses the pomegranate as a symbolic centre piece here. The pomegranate (*Punica granatum*), which is approximately the size of a big orange, is divided into chambers containing many seeds. It is considered indigenous to Iran but is now found worldwide.

Fig. 2.2 *White Wolf with Mother Earth* (2000, Wuriqiefu)

Description of the piece: What the pomegranate represents here is the diverse identities of Mainland China, with each seed symbolizing a Minzu 'ethnic' group dressed up in their traditional costumes and headdresses. Its red colour is meant to represent the unity of these diverse groups (one of China's motto is *Unity in Diversity*, which is similar to, e.g. the EU motto). This colour is thought to be auspicious and has been traditional for a long time in China. As such red is used during Chinese Spring festival ('Chinese New Year'), weddings and other celebrations and is considered as a very positive and powerful colour.

Problematizing identity through the piece: Using the pomegranate as a symbol of unity is a direct reference to a political statement made by Chinese President Xi to refer to Chinese unity (Yuan et al., 2022). Since the artist works at a Minzu institution which aims to promote Minzu understanding and relations in China, this work of art represents his artistic and civic contribution to promote brotherly Minzu relations as well as collective identity. In the artwork, collective identity is depicted as being

much more important than individual identity, as if the artist were saying 'no matter where are you from in China, we are family'. Finally, like pomegranate seeds inside the fruit, the different members of Minzu groups seem to be tightly connected and united in the artwork. By using a piece of art that is reminiscent somehow of traditional Chinese paper-cut, the artist 'localizes' this message. Identity metamorphoses here might relate to the constant need to strengthen unity between groups of diverse people while accepting their own diversities.

The second piece is by Wuriqiefu: *White Wolf with Mother Earth* (苍狼与大地, 2000).

Basic information about the piece: White Wolf with Mother Earth is about 60 × 71 cm and was executed with the silk screen (printing) technique. The artist, Wuriqiefu, is a member of the Mongolian Minzu group (North of China). He made this art piece as part of his PhD studies at the Central Academy of Fine Arts of Beijing and is currently a Professor of Arts at Minzu University of China. The inspiration for the artwork is from Chinese Mongolian totem worship and folklore.

Description of the piece: While the 'shape' of the artwork resembles a pyramid, the centre of the piece is filled with a semicircle representing the earth. One can see a faint reflection of a group of wolves in the melted red earth. At the highest point of the earth, a white wolf is shown howling towards the sky and moon, a large black sky and a half-moon eclipse echoing at the top. The artwork has to do with Mongolian grassland ecology and the close relationship between man and nature. The grassland and the wolf represent special elements for the artist's own Mongolian Minzu identity. In the traditions of Chinese Inner Mongolia, the grassland stands for the 'mother' of all, and wolves represent and symbolize courage, strength, wisdom and teamwork spirit.

Problematizing identity through the piece: The artist seems to want to share his strong sense of belonging to a specific Minzu group through the vivid depiction of many Mongolian elements in his painting. This powerful piece of art problematizes the links between personal and collective identities. Identity metamorphoses here might have to do with collective and personal identities connecting with Mother Earth through the metaphors of the grassland and the wolves.

[THINKING FURTHER]

1. How would you represent artistically some of the groups you belong to (e.g. nation(s), institution(s), groups of friends and relatives)?
2. Most of us will have had a portrait of themselves done as a painting, sculpture or photography. In fact, you might have taken a selfie just before opening this book. Increasingly, we have the opportunity to produce and observe representations of self (and others with self). If you have such *re*-presentations at hand, have a look at several of them and reflect on how they make you feel about your own identity metamorphoses. If you have such portraits containing other people too, reflect on what these pieces show of your connections to them.
3. What do you make of the Chinese thought of Zhongyong when you look at the two art pieces? How would you summarize the main features of Zhongyong for yourself?
4. Go back to the pieces presented in the chapter. Are there extra aspects of identity metamorphoses and interculturality that we, the authors, have missed? What is it that you see that we did not pay attention to in our discussions?
5. While reading this chapter, have you been able to enrich your own take on identity, especially in relation to interculturality? Can you think of specific intercultural encounters and experiences that were meaningful to you and how you would now read them through the lens of identity metamorphoses?

SUGGESTED READING

Bauman, Z. (2004). *Identity: Conversations with Benedetto Vecchi*

This book is based on interviews between an Italian journalist and the late British sociologist Zygmunt Bauman (1925–2017), a major thinker of postmodernity. In their discussions, the authors draw conclusions about the insecurity and uncertainty of our times, arguing that we have no other choice but continually transform in order to be able to face these stressful phenomena. As a result, identities are 'liquid', transient but also precarious and elusive. This book can inspire to unthink and rethink identity continuously.

Buber, M. (2000). *I and Thou*

Martin Buber (1878–1965) was a philosopher of encounters, alterity and reciprocity who had a large influence on major thinkers of the twentieth century such as Husserl, Heidegger, Sartre and Lacan. In this book Buber puts forward two types of relations to others—which have different impacts on the way we identify: The *I-it relation* (the other who can be manipulated as an object) and the *I-Thou relation* (the other as a profound partner in encounters).

Dervin, F. (2016). *Interculturality in Education: A Theoretical and Methodological Toolbox*

This book helps us explore the notion of interculturality in education and other fields, offering a rich and realistic understanding of the 'intercultural'. Concepts discussed in our chapter (e.g. culture, identity) are presented and revised as well as myths about them. All in all, this book aims to propose a useful framework to address theoretical and methodological issues related to identity and interculturality.

Rebel, E. (2020). *Self-Portraits*

This Taschen book presents 33 self-portraits from the fifteenth century to today (e.g. Dürer, Kahlo, Schiele). It helps us grasp the evolution of this artistic genre and problematize selfhood, self-representation and otherness at the same time. Notions of beauty, power and status are discussed alongside the multifaceted methods and approaches artists have used over the centuries.

REFERENCES

Bauman, Z. (2004). *Identity: Conversations with Benedetto Vecchi.* Polity Press.
Baumann, G. (1995). *Contesting Culture: Discourses of Identity in Multi-Ethnic London.* Cambridge University Press.
Buber, M. (2000). *I and Thou.* Continuum.
Canetti, E. (1989). *The Secret Heart of the Clock.* Farrar Straus Giroux.
Canetti, E. (2021). *Notes from Hampstead.* Macmillan.
Cassin, B. (2016). *Éloge de la traduction. Compliquer l'universel.* Fayard.

Dervin, F. (2016). *Interculturality in Education: A Theoretical and Methodological Toolbox.* Palgrave Macmillan.

Dervin, F., & R'boul, H. (2022). *Through the Looking-glass of Interculturality: Auto-critiques.* Springer.

Etymonline. (2022). Metamorphosis. https://www.etymonline.com/word/meta morphosis#etymonline_v_14709

Fan, K. (2018). *Identity, Culture, and Local History: Anthropological Approach (认同、文化与地方历史:人类学的理论探讨与经验研究).* Social Sciences Academic Press (China).

Ghaffour, M. T. (2022). Anti-Essentialist Culture Conception for Better Intercultural Language Teaching in EFL Contexts. *Arab World English Journal, 13*(1), 273–284.

Hai, L. (2018). Identity(认同). In J. Wang & R. Na (Eds.), *Encyclopedia of Cultural Anthropology (文化人类学百科全书)* (pp. 430–432). Wenjing Publishing House.

Halualani, R. T. (2017). *Intercultural Communication: A Critical Perspective.* Cognella Academic Publishing.

Han, B. C. (2020). *The Expulsion of the Other: Society, Perception and Communication Today.* Polity.

Holliday, A. (1999). Small Cultures. *Applied Linguistics, 20*(2), 237–264.

Holliday, A. (2011). *Intercultural Communication and Ideology.* SAGE.

Key Concepts in Chinese Thought and Culture. (2022). Zhongyong (Golden Mean). https://www.chinesethought.cn/EN/shuyu_show.aspx?shuyu_id=2179

Levi-Strauss, C. (1977). *L'identité.* Grasset.

Maffesoli, M. (1997). *The Time of the Tribes.* Sage.

Rebel, E. (2020). *Self-Portraits.* Taschen.

Roald, T., & Lang, J. (2013). *Art and Identity: Essays on the Aesthetic Creation of Mind.* Rodopi.

Sen, A. (2006). *Identity and Violence.* Penguin.

The Cambridge Dictionary. (2022). Identity. https://dictionary.cambridge.org/dictionary/english/identity

Tian, X., & Dervin, F. (2022). Intercultural Communication Education beyond 'Western' Democracy- Talk? Zhongyong as a Way of Decentering Democracy-Based Teaching. In J. Zajda, P. Hallam, & J. Whitehouse (Eds.), *Globalisation, Values Education and Teaching Democracy.* Springer.

Troisi, A. (2017). *The Painted Mind. Behavioral Science Reflected in Great Paintings.* Oxford University Press.

Wikan, U. (2002). *Generous Betrayal.* Chicago University Press.

Yuan, M., Dervin, F., Sude, & Chen, N. (2022). *Change and Exchange in Global Education—Learning with Chinese Stories of Interculturality.* Palgrave Macmillan.

Zhao, J. (2015). *Cultural Memory and Identity (文化记忆与身份认同).* SDX Joint Publishing Company.

(Re-)encountering

Abstract This chapter focuses on the topic of encountering, problematized through the addition of the prefixes re- and mis- (re-encountering, mis-encountering). After dealing with the notion of intercultural encounters, the authors explicate why intercultural encounters should always been seen through the lens of dialogism—considering them as encounters that contain traces of other encounters (*re-*). Four concepts are then introduced to reinforce our understanding of re-encountering: *face, mask, mirror* and *language*. These allow us to engage with re-encountering in more dynamic and multifaceted ways in intercultural situations. Finally, three different art pieces are reviewed to reflect on the need to deepen our takes on meeting others.

Keywords Encounters • Face • Mask • Mirror • Mis-encounters

[THINKING FIT]

1. Can you remember any piece of art that depicted an encounter, a meeting of people, people-things and people-animals? How was the encounter problematized through the use of, for example, colours,

© The Author(s), under exclusive license to Springer Nature
Switzerland AG 2023
F. Dervin, X. Tian, *Critical and Reflective Intercultural
Communication Education*,
https://doi.org/10.1007/978-3-031-40780-2_3

shapes, forms, movements and techniques? What did the art add to the encounter? How did it depict people's feelings during/about the encounter? How did it try to trigger reactions in you?

2. Look at art pieces that you may have at home or pieces available in public places. How many of them depict encounters or invite you to meet someone or something? What artistic strategies are used to do so?

3. Has a piece of art representing encounters made you think of a specific encounter you have had?

4. Has art depicting encounters triggered strong feelings in you? Why? How did you deal with them?

5. Have you ever met someone around a piece of art? In other words, has art allowed you to meet someone? Did the art become some sort of a symbol or memory of your encounter?

Encountering Is Meeting Again

This chapter revolves around the idea of encountering or to be more precise *(re-)encountering*. The word *encounter* in English comes from old French *encontrer* (to meet) which used to mean *to meet as an adversary*, built upon another word for *a meeting, a fight or an opportunity*. The Latin word from which it originates contains the ideas of *counter, against*, but also *in front of*. So, encounters were at first considered through the lens of confrontation.

While English borrowed the verb directly as is, contemporary French says *rencontrer*, which translates literally as *to meet again*. By adding (re-) in front of encountering in the title of this chapter we want to suggest that meeting someone always starts before we really meet them. As such meeting someone usually involves relating the person and the situation of encounter to other moments and previous moments of encounters with others (a smell, a face, an accent or a piece of clothing worn by someone will always remind us of a previous experience). Bakhtin (e.g. 1982) and others have addressed this issue through the notions of dialogism (we always dialogue in-/directly with others in all situations) and intertextuality—or the idea that every text (in the broad sense of the word: pictures, sounds, objects, etc.) is always embedded in other texts.

[*I see a face, I see the person in front of me, but at the same time I can see other people in them. I never encounter but I re-encounter the world all the time.*]

Let's look at the word encounter in different languages for a minute:

Renkonti (Esperanto); Begegnung (German); એનકાઉન્ટર (Gujarati); la kulan (Somali); Kukutana (Swahili).

How many of these words remind you of words that you know to refer to meeting someone/something in other languages? How many of these words seem to portrait well visually (like art) encounters? Why (not)? Try to listen to the words online and to figure out what images of encounters they bring to your mind.

Let's focus for a moment on words in three of our languages: *Chinese, Finnish* and *Icelandic*. These will give us extra inspiration to problematize encounters for art and interculturality.

Like many other languages, there seems to be a range of words used to refer to the idea of encountering in Chinese (simplified writing): 遇到, *encounter, run into, come across*, but also *touch* (the last character hinting at *arriving* and the direction *to*); 碰到, with the same last character, translates as *bump into* and *touch*; and 逅 means *to meet unexpectedly*. In Finnish, encounter translates as *kohtaaminen*. The word can refer to *an unplanned meeting* but also *an encounter with supernatural beings* ('visitation'). The word can also be used to say 'interviews'. *Kohdata* is *to face* and *to confront*, while *kohta* translates as *a place* (in a text, paragraph, section), *soon, within a short time*. Kohtaan is *toward(s)* and *to*, indicating a direction, a cross-over to someone/something. Finally, in Icelandic one word for encounter is *fundur*. The reader will notice straight away that the word also has to do with the idea of finding and discovering in the English language.

[Drawing some brief conclusions from these words in other languages, encounters occur across, towards; they touch us and urge us to touch each other; encounters aim to make us discover self and other.]

THE IDEA OF *ENCOUNTERS* WITHIN INTERCULTURALITY

You might have seen the word encounter being used with the notion of interculturality in English and other languages. Yet, it is not a very common 'label' in research and education. In what follows we explore a few contexts where the word *encounters* is currently used in relation to the 'intercultural' so that we can get further ideas to un-/rethink about 're-encountering' interculturally.

The first use of the label that comes to mind is a master's programme from our own university (Helsinki), which is, to our knowledge, the only such programme in the world to have included encounters in the name of a master's programme. A non-systematic online search shows that the following labels are used in other contexts:[1]

1. *Intercultural communication* (e.g. Penn State University, US; Utrecht University, The Netherlands)
2. *Intercultural studies* (e.g. Columbia International University, USA; Aarhus University, Denmark)
3. *Intercultural and International Communication* (Royal Roads University, Canada)
4. *Intercultural Management* (e.g. Paris-Pantheon-Assas University, France)
5. *Migration and Intercultural Relations* (e.g. The Carl von Ossietzky University of Oldenburg, Germany)
6. *Human Rights, Interculturality and Development* (e.g. Universidad Internacional de Andalucía, Spain)
7. *Intercultural Development of Tourism Systems* (e.g. Università Ca' Foscari Venezia, Italy).

In total (alphabetically): *communication, relations* and *studies* but also *development, interculturality and management*. Often the labels are chosen with specific fields, interdisciplinarity, but also marketing in mind. So, what seems special about the Master's in intercultural encounters? What does *encounters* mean here?

The programme is described as 'interdisciplinary', aiming to 'enhance your thinking and grow your expertise in cultural understanding' (Helsinki. fi, 2022). Mentions of 'professional life', 'theoretical thinking' and 'practical research skills' are identified, which seem to give the programme a 'professionalizing' flavour. Reading through the programme website, we note that intercultural encounters are not really defined. We are told that 'Intercultural encounters remain in the news year after year. There is an

[1] We focus only on the use of the word *intercultural* here. We are aware that many programmes (like in research terminologies) make use of notions such as *multicultural, cross-cultural, transcultural* and *global*. Choosing intercultural for either a master's programme or project name is usually not random and has to do with economic-political beliefs combined with 'research' ideologies.

ongoing need for multidisciplinary approaches for understanding' (Helsinki.fi, 2022) [shifts between *intercultural* and *cultural, interdisciplinary* and *multidisciplinary* are often operated on the website. The 'differences' between these elements are never clarified]. The programme goals mention 'multifaceted understanding of intercultural encounters', 'training in intercultural competence' and 'the ability to apply scholarly knowledge and conduct scientific research' (Helsinki.fi, 2022). Finally, the website tells us that 'Upon completing the ICE programme, you will be able to act and grow in multidisciplinary and multicultural groups. In addition, you will be prepared to navigate issues of intercultural interaction, diversity, internationalisation, media and power' (Helsinki.fi, 2022). Intercultural encounters seem to englobe *intercultural competence, interaction and diversity; learning to 'act' and 'grow' in 'groups'; inter-/multidisciplinarity (research)*; and *internationalization, media and power* (but also *religion*). The label thus appears to be a big 'bag' of 'issues' that may have to do with 'international levels' [a 'ghost' that is never really stated in the programme description: *are intercultural encounters international and/or something else?*].

From the 'corner of the world' called Europe, the word encounters also brings to mind the *Autobiography of Intercultural Encounters* of the Council of Europe. This document was produced for the Directorate General of Democracy and Human Dignity of the supranational institution. The two tools produced for the autobiography in English and a few other languages, with versions for young learners and older learners and adults (*Autobiography of Intercultural Encounters* and *Images of Others: An Autobiography of Intercultural Encounters through Visual Media*), aim to 'encourage people to think about and learn from intercultural encounters they have had either face to face or through visual media such as television, magazines, films, the Internet, etc.' (COE, 2022a). The authors of the autobiographies propose the following basic definition for intercultural encounters in their glossary of key terms:

An intercultural encounter is an interpersonal encounter where there is some significant difference in cultural identities, backgrounds, worldviews, and practices between the participants involved. (COE, 2022a)

Let's pause here for a moment. What we learn from these pieces of description is that intercultural encounters can be face-to-face and/or mediated (e.g. computer-based). The focus appears to be on difference with

elements such as cultural identities and 'backgrounds' (nationality? Heritage?). Such encounters involve 'participants' (a word from Latin meaning *partaker, comrade* and *fellow soldier*) and 'persons' (see 'interpersonal') who are said to be 'different'.

On the autobiography website, an online self-study course for educators (COE, 2022b) proposes a certain number of activities around intercultural encounters. A module aims to support educators understand the idea of intercultural encounters. The following (somewhat surprising) keywords are proposed for the module: clash, intercultural encounter, common ground, context of encounter, cultural immersion and cultural programming. These all seem to spell out the ideological takes of the autobiographies on intercultural encounters (e.g. culture, conflict-consensus). The module is described as follows:

> An intercultural encounter may mean different things to different people depending on their personal and work contexts. In this module you explore your own understanding of intercultural encounter and that on which the Autobiography of Intercultural Encounters (AIE) is based. You consider the areas of life in which intercultural encounters may take place. Finally you reflect on an intercultural encounter of your own using the AIE to guide you. (COE, 2022b)

It seems that the idea of the module is to make educators reflect on their own and others' take on intercultural encounters but, more importantly, to 'teach' them how the autobiographies are positioned in relation to the term—seemingly 'winning over' other definitions. A first activity presents several definitions of the term for educators to reflect on their similarities and differences, to 'rank' them and eventually to 'refine' their own thinking—*in line with* the autobiographies. [An example of a definition: 'encountering someone from another cultural background implies an encounter not only with an individual, but with the hidden assumptions of that person's worldview' (COE, 2022b)]. We note that there is no indication of authorship for the definitions to be reflected upon.

Another activity from the module guides educators to reflect on their own 'circles of intercultural encounters'—which are also referred to as 'social and cultural worlds' (COE, 2022b). In this activity we are asked to draw circles related to the *interpersonal, institutional, local* and *global* and to write down two of our own intercultural encounters and to reflect on 'positive' and 'negative' aspects of these encounters. The 'level' and

'nature' of intercultural encounters become clearer with this activity; for the authors of the autobiographies, such encounters can relate to, for example, 'ethnicity, nationality, language, religion, lifestyle, profession and family roles' (COE, 2022b).

We do not propose a critical review of the content of the (European) autobiographies of intercultural encounters here. Should you wish to read more about what they 'do' to people in different 'Western' countries (and beyond), the following papers provide diverse opinions and positionings on the topic:

1. María del Carmen Méndez García (2016) Intercultural reflection through the *Autobiography of Intercultural Encounters*: students' accounts of their images of alterity.
2. Melina Porto (2019). Using the Council of Europe's autobiographies to develop quality education in the foreign language classroom in higher education.
3. Carl Ruest (2020). The *Autobiography of Intercultural Encounters*: mixed results amongst Canadian adolescents.

Before we draw some general conclusions about the use of the word encounters in relation to interculturality from this small selection of educational elements, let us review some books published in recent years (2019–2022) in English with international publishers that contain the word *intercultural* and *encounters* in their titles. We do realize that this is a limited approach since the use of the word may be marketing oriented (sometimes imposed on authors by editors) or underexplored in the very book. However, we are curious about the presence of encounters in books that have to do with interculturality: what do the authors seem to be telling us about the two terms? In total we have identified seven books:

1. *Intercultural Encounters in medieval Greece After 1204: The Evidence of Art and Material Culture* (Kalopissi-Verti & Foskolou, 2022)
2. *Human Encounters: Introduction to Intercultural Communication* (Dahl, 2021)
3. *Robert Lepage's Intercultural Encounters* (Carson, 2021)
4. *Rethinking Culture in Health Communication: Social Interactions as Intercultural Encounters* (Hsieh & Kramer, 2021)
5. *Intercultural Service Encounters: Cross-cultural Interactions and Service Quality* (Sharma, 2018)

6. *Screens and Scenes: Multimodal Communication in Online Intercultural Encounters* (Kern & Develotte, 2020)
7. *International Students in China: Education, Student Life and Intercultural Encounters* (Dervin et al., 2019).

Encounters is combined with intercultural in most of these titles, with a few added words such as *online* and *service*. One book deals with *human encounters* (which becomes *intercultural communication* in the subtitle). The fields appeared to be varied: history, communication, health, service, applied linguistics and education studies. We have also identified six books that combine encounters and words somewhat synonymous with intercultural:

1. *Encounters with Emotions: Negotiating Cultural Differences since Early Modernity* (Gammerl et al., 2019)
2. *Transcultural Encounters in Knowledge Production and Consumption* (Song & Sun, 2019)
3. *Cross-Cultural Encounters in Modern World History, 1453-Present* (Davidann & Gilbert, 2019)
4. *Theories of the Stranger: Debates on Cosmopolitanism, Identity and Cross-Cultural Encounters* (Marotta, 2020)
5. *Cultural Encounters as Intervention Practices* (Christiansen et al., 2020)
6. *Sino-German Encounters and Entanglements: Transnational Politics and Culture, 1890–1950* (Cho, 2022).

Cross-cultural, cultural, cultural differences, Sino-German and *transcultural* 'qualify' encounters here. Most of the books have to do with history and the topics of strangeness, interventions and knowledge production/consumption.

To conclude this short exploration of *intercultural + encounters* in research, (higher) education and supranational politics, it seems that the word *encounters* is a polysemous and fluid term that is not always problematized, although there are indications that they might have to do with history for some researchers. We note that what the term encompasses seems to be broad, from international to 'family' matters. It also has to do with 'face-to-face' and 'digital' interactions between people and with, for example, objects and knowledge.

In what follows we develop our own understanding of encounters, especially through the idea of (re-)encountering. Three pieces of art will help us explore these elements further.

FACE, MASK, MIRROR AND LANGUAGE

In this section, four keywords help us problematize encounters and (re-) encountering. Some readers will most likely have other keywords in mind, and we urge them to reflect actively on them too, after reading this chapter.

In Fred's research on intercultural encounters (e.g. Dervin, 2016, 2022), which has usually involved people from different parts of the world, he has used a theory entitled dialogism inspired by the work of the literary critique Mikhail Bakhtin (1895–1975). This theory maintains that any encounter is always embedded in previous (real and/or imaginary) encounters with other people. This means that meeting someone for the first time always involves finding connections to other situations, words and faces that we have come across in earlier situations of encounters. When we meet interculturally, there are always multiple voices between us—the voices of those we have met or ideas that we have been introduced to. All these usually influence the way we treat others and speak to each other. They might also give us the illusion that we already know the other. For example, national stereotypes about other people contribute to mis-reading the other. These are always illusions because what we see in the other can never match how they see themselves, their own complexities—the same applies to our own self. So, when we talk to each other, we are surrounded by invisible (and often uninvited) figures, entities from past interactions with others, things, knowledges, experiences and ideologies, that influence what we 'do' and say with each other. The theory of dialogism also reminds us that dialogue is not just between two persons but that it often happens within each person (Markova et al., 2007). As we interact with others, we interact in-/directly with ourselves. This is often referred to as internal dialogue (e.g. when we ask ourselves: 'Can I say this?'; 'Why do I feel that I cannot trust this person?'). It is also important to remind ourselves that we might tend to silence and censor ourselves while interacting with others for different kinds of reasons. Thus, encounters are filled with multiple voices, some identifiable and others hiding in the corner of our minds, mouths and ears. These complex processes, of which we are not always in control (someone might 'see' a positive/negative voice in us, of which we might be unaware), also impact the way we

co-construct identities *with* and *for* others. The resulting identity work is that of encounters and dialogues between self and other, self and self, and other and other.

[You wake up in the morning and look at yourself in the mirror. You had a good night sleep. Your face looks smooth, flawless, with a beautiful smile. Two hours later, you had a call from a colleague, of whom you are not very fond. You look at yourself in the mirror again, your smile is gone, your lips look tighter, and your eyes are full of anger. At bed time, you look at yourself one last time. You notice a small wrinkle above your left eyebrow, your nose is greasy, and your beard has grown again. *Your faces.*]

The first concept that we review for discussing (re-)encountering is that of *face*. There are billions of people on our earth and many more billions of faces. A face is never static; it changes every second of our life. Muscles, organs and their interaction with air and the environment reshape our faces all the time. There are not two faces in the world that are alike. Our own face is never really the same, and with the current (widespread) use of, for example, beauty filters on our phones and even plastic surgery, we're never really the same. The presence of others, their kindness, their arrogance and their attractive or repulsive looks all impact on our face. The environment, pollution and what we eat mould our face too.

The Finnish language seems to be the only language in the world that uses a plural word to refer to someone's face (*kasvot*). While in English we say 'my face is dirty'. In Finnish one needs to formulate it as 'my faces are dirty'. The word *kasvot* symbolizes the complexities and metamorphoses of identity with and for the other. Because of this complexity, we always re-encounter each other. In the apparent simplicity of someone else's face and in our own, we see others, other situations, other feelings, other experiences and other ways of understanding life and the world of which we might be aware or have experienced before.

The following key terms also come to mind: *mask, eyes (stare), ears* and *dialogue*. The face has often been discussed in philosophy. For example, in his philosophy of the other, Levinas (2017) places the face at the centre of togetherness. It is through this part of our body that we consider the other, we look at them, we send verbal signals through the face, we use our face to express emotions, etc. [In old English *a facial meeting* meant *to meet face-to-face*.] The word face in English has to do with old French (and Latin) for 'form imposed on something' (*facere* in Latin means *to make*). We note that the idea of 'losing face' dates back to 1835 and is directly from Chinese. Many idioms are found in the English language

with a direct reference to the face: *to put the best face on (something) [highlighting positive aspects of a difficult situation]; to pull a long face [appearing depressed or concerned]; to keep a straight face [preventing oneself from showing feelings on one's face]; to get egg on the face [feeling humiliated]; blue in the face [exhausted because of annoyance].* All these show the centrality of the face in front of the other; face appears to be the centre of emotions, identities and 'real self' in these idioms. They seem to indicate that one needs to balance what the face reveals of us in front of others.

In the Chinese language, many different phrases refer to *losing/saving face*: (amongst others) 丢面子, 丢丑; 跌份 (colloquial with the idea of lower in value). A few interesting phrases about *face* in Chinese (simplified writing) are shared below:

1. 死要面子 translates as 'dead determined to save face', 'keep up appearance to cover up' or even 'to consider loss of face unthinkable' (死 means *die*).
2. 洗心革面 means to wash one's heart and renew one's face (i.e. to turn over a new leaf).
3. 文面 used to refer to an ancient form of punishment whereby the face of a criminal was tattooed (NB: the character 文 is also found in the Chinese words for culture and civilization).

[Face appears to be something that we protect in front of the other.
Face can betray our feelings and what we 'really' think.
Face seems to present some form of truth that we wish (we could) to conceal at times.
Face can speak more than we might think.]
['No man, for any considerable period, can wear one face to himself and another to the multitude, without finally getting bewildered as to which may be the true'. Hawthorne (2009: 147)]

The image of the mask (another important concept) has been used in different contexts to problematize face: *philosophy, sociology, art, music,* etc. In one of the rare books where the mask is problematized in relation to interculturality, *Between the Masks: Resisting the Politics of Essentialism,* Brunner (1998) offers a critical reflection on identity, resisting what she refers to as 'essentialist politics' and 'illusions of identity' in education, i.e. misrepresenting and forcing the other through 'our' own stances. We feel

the need to remind our readers here that the very word person comes from Latin for a mask.[2] Etymonline (2022) explains:

> from Latin *persona* 'human being, person, personage; a part in a drama, assumed character,' originally 'a mask, a false face,' such as those of wood or clay, covering the whole head, worn by the actors in later Roman theater.

A mask is a 'false face', as is confirmed by the etymology of the very word, which has probably 'travelled' from Arabic *maskharah* for 'buffoon, mockery'. The English word also finds its origins in words from both Italian and Medieval Latin referring to *specter* and *nightmare*. We note that in Chinese a mask is literally a 'face tool', 面具, with the first character showing a person's face [面 can also mean noodles and surface]. The masks we wear with others and the masks we impose on them and them on us (reciprocally or not) are part of the social 'games' that we play with each other and relate to (unfair, unbalanced) power relations linked to, for example, economic, gender, national statuses, protection of one's deep 'secrets' as well as our (often fantasized) wish to protect others (see Hawthorne above).

[With the global use of COVID masks after 2020, we all have had to learn to communicate with our faces in different ways, since we could not use the lower part of our faces. One Chinese student, in a discussion with us, told us that he had learnt to smile with his eyes to interact with others and make people feel comfortable. Our face as mask is a 'tool' to refer back to the Chinese language, and yet the material masks that we put on our face such as surgical ones or religious veils require us to find new ways of signalling to the other that we are with them and that we are interacting with them.]

Resorting to masks to meet others represents a good way of protecting ourselves from potential harm from others, from being (mis-)judged, (mis-)presented and (mis-)labelled. There is of course no guarantee that silenced realities and censored utterances will protect us from the other and vice versa.

We now come to the topic of *stare*, which is a common approach to the other. In the English language one might think of the following words as synonyms of stare: ogle, pry, scrutiny, blink, gawk and gaze. All these words indicate the use of our eyes to consider the other, to 'communicate'

[2] We note that the word *larva* comes from Latin for a ghost, a spectre, but also a mask. Before a larva becomes, e.g. a butterfly, it is a 'mask'.

visually. What we communicate with staring can vary, from mere curiosity to hatred and from indifference to lust. From our own intercultural experiences, we feel that different contexts might be more or less tolerant of staring. For example, it is not uncommon for some people to stare insistently at foreigners and even to point at them in China. This is not necessarily considered as 'racist', 'anti-foreign' or 'aggressive' but, often, a mere sign of curiosity for the other (Liu & Dervin, 2022). Looking at each other 'in the face' is actually an important component of encountering. What is specific about stares (from strangers) is that, usually, no words and no verbal exchange between those involved are occurring. Just their eyes consider each other in certain ways. A stare can have, obviously, different meanings, depending on what facial and body elements do as accompaniment. They might say: *You look interesting. Where are you from? What are you doing here? I wish I were your friend. Do you fancy me?*

Our last concept related to (re-)encountering is the mirror. *The face, the mask* and *the stare* all hint at the process of mirroring that we experience in front of others. *I see you, you see me, I see myself in you and you see yourself in me.* All these *I*s and *we*s that we see are not necessarily some kind of realities of self and other but projections of what we wish to see or what we think we are seeing. Faces, masks and stares transport us into the other (an imagined other). We compare and contrast I and you in the process and find similarities and differences, preferences and dislikes, dreams, fantasies and realities. We might notice new perspectives on ourselves in the mirror of the other. More importantly, the mirror of the other can lead us to change with them or alone. Re-encountering here also has to do with the reflexivity of seeing oneself as similar and/or different with what we see in the other and them in us.

Before we observe three pieces of art to reflect further on re-encountering, we must tackle the central issue of language. In what we discussed hitherto, language was 'underground'. It is part of the face (ear, mouth), and it is through it that we can 'face' the other, mirroring each other and doing the 'inter-' of interculturality. Language here does not just refer to speaking, but it has to do with all language skills (reading, listening, interacting, etc.) as well as other forms of language that are part of our communicative systems (non-verbality, postures, gestures). Language is hard to control, and face in re-encountering, as we have seen, often has to do with regulating somehow what our face can tell others that would say too much or too little and have an influence on what we do together. A lot of what we express through words or gestures can lead to

misreadings (misunderstanding, nonunderstanding). For Kafka
(1983: 175):

> I am constantly trying to communicate something incommunicable, to
> explain something inexplicable, to tell about something I only feel in my
> bones and which can only be experienced in those bones. Basically it is noth-
> ing other than this fear we have so often talked about, but fear spread to
> everything, fear of the greatest as of the smallest, fear, paralyzing fear of
> pronouncing a word, although this fear may not only be fear but also a long-
> ing for something greater than all that is fearful.

What we do together is to try to cooperate with each other, like water
control gates of a canal. We pull from one side and then the other, and
sometimes the system is disrupted and stops working. The performance
that we described when we spoke of the mask has to do with these pro-
cesses. The masks which we 'articulate' by means of language represent
attempts to make sure that acts of communication are somewhat smooth
[in reality, one can never really know if they are], so that we can show a
positive face to each other (Goffman, 2017) and to please each other. At
times, the use of language and the masks that filter it can also be used to
mislead others (each other?) and to impose one's power on others. Finally,
we note that silence and the refusal to speak with others (for reasons such
as discriminatory practices and censorship) also constitute aspects of re-
encountering in interculturality.

In summary, *re-encountering* interculturally necessitates and entails:

1. Being face-to-face or in mediated interaction with people, things
 and knowledges
2. Considering any situation of encounter as an intercultural event
 grounded in every single person's diversities, beyond the mere
 international
3. Looking at self, other our immediate contexts and the world
 through the unstably constructed continuum of difference and
 similarity
4. Looking into the mirror of the other, to see oneself, people around
 us, our ideologies and beliefs, and our worlds and to reflect on
 these elements towards potential change

5. Making connections between what we hear, experience and see at moment X to other past, projected and fantasized moments of encounter with other people or the same people
6. Carefully manipulating and navigating the different masks that we all wear to get to, consider, understand, attract and please each other
7. Considering the eyes of the other as an invitation for (silent) dialogue
8. Accepting that we are not in control of language and that misreading is 'normal'
9. Refusing to speak because of a topic or a person who makes one feel uncomfortable
10. Confronting oneself with situations and discourses with which we don't feel comfortable
11. Juggling with language (e.g. words, facial expressions, postures and smells) with and for the other in support of ('comfortable') ('pleasant') identity constructions.

REFLECTING ON MIS- AND RE-ENCOUNTERING THROUGH ART

This section focuses on three artworks to illustrate encountering. Two were produced by Chinese artists and one by one of us in the Chinese context. The topic of these pieces is re-encountering, with a focus on what we wish to call here mis-encountering. The common point between all the characters depicted in the pieces is that they re-encounter while mis-encountering. They are together, they are embedded in different 'structures of encounters' and yet they seem to be floating past each other. The contexts of encounters in the paintings vary, and yet they all have to do with some form of interculturality.

The three pieces are *One or the other* (非此即彼, 2009) by Hu Changqiong (Fig. 3.1), *Diptych* (对视双联画, 2020) by Xi Peng Cai (Fig. 3.2) and *Where are you from? II* (2022) by Fred Dervin (2022) (Fig. 3.3). Before we start exploring them one by one and then together, look at the three art pieces and reflect on the following questions:

1. How big do you think each art piece is? What kind of material(s) did the artists use and for what potential purposes and effects?
2. Try to explain to yourself what the artist is trying to say through the paintings. What are they doing with the characters they have included?

Fig. 3.1 *One or the other* (2009, Hu Changqiong)

3. Why do these pieces represent *re-encountering while mis-encountering*? How common such phenomena and processes are to you?
4. What artistic and visual strategies do the artists use to represent these phenomena and processes?
5. Observe how the different characters' eyes and other facial features might inform us of what they are thinking and doing (mis-)(re-) encounter-wise.
6. What might the characters be thinking and saying to each other (and to those outside the framework of the art pieces)?
7. Look at the context where they are located and the inclusion of specific spatial elements and objects, what dimensions do they add to the idea of re-encountering while mis-encountering?

We start our discussion of re-encountering while mis-encountering with *One or the other* by Hu Changqiong (Fig. 3.1).

Basic information about the piece: One or the other is a large painting measuring 169 × 114 cm. The technique used by the artist is tempera on wood (a method of painting where colours are mixed with egg and water instead of, e.g. oil). The style of the painting appears to be a mix of realism

Fig. 3.2 *Diptych* (2020, Xi Peng Cai)

and dreamlike representations of both the characters and the place. It was produced at the end of the early 2000s by Hu Changqiong for his Master's graduation from the Oil Painting Department of China Academy of Fine Arts (CAFA, Beijing). He is now a professor at the same institution.

Description of the piece: The painting contains six characters, with the artist having included himself in the piece on the left front side. He is the only character looking towards us, holding his head up. The characters are spread out on the large painting. The five other characters are members of the artist's family. On his right, there is his wife, with a red character (who seems to form her shadow) behind and next to her. The wife is looking down, with a stern, empty and somewhat sad expression on her face. At

Fig. 3.3 *Where are you from? II* (2022, Fred Dervin)

the back, on the right, looking down to the right of the painting, towards the smoke of a factory, one sees the artist's mother. On the left side, the artist's best female friend is looking in the opposite direction of the mother. It is unclear if she is looking away or focusing on something or someone. Like the father in the middle, the colours seem to indicate that the friend is 'unreal' and/or 'dreamlike'. One can feel the personality of the father in the way he is depicted. His face is red/blue, and he is staring at the young couple, looking somewhat angry. The sky behind the three dreamy characters appears to be threatening. Tension can be felt. While the couple appears to be 'grounded', the three other characters are standing in the background, in the sky, above the landscape.

Problematizing re-encountering through the piece: This artwork is about a specific form of interculturality: (a lack of direct) communication within

a family. Obviously, all these people have a history together, and one can see on their faces that they know and feel things about each other. For us, what the painter describes well here is (silenced?) silence between the characters; they are together, and yet they *mis-encounter*. There are a lot of unsaid words on their faces. The fact that they either look away or ignore each other reinforces the tensions one can feel in the painting. One can also feel different kinds of pain in each character. For example, according to the artist, the red figure behind and next to the wife represents her unhappy and depressed self. The landscape shows the artist's industrial hometown in China (Zhuzhou, Hunan Province, Southern China, a city of about four million people, 1500 km from Beijing). For Chinese people, the idea of the hometown (the place where their family comes from) is an essential aspect of their identity. In the art piece, nature seems to dominate, with hilly landform, with the Xiangjiang River in the middle which forms a central point in the representation of the town. The colourfulness of the landscape seems to contrast with the characters while dialoguing with some of them (e.g. the colours used in the father figure).

The second piece is by Xi Peng Cai (2020). It introduces forms of mis-re-encounters that are found within the realm of public spaces (Fig. 3.2).

Basic information about the piece: While the first piece was about re-encounters between people who have known each other for a long time, *Diptych* depicts young people walking down the stairs and going up escalators in what could be a mall or a subway station. The location is unknown, but we assume that it is in a city in China. The piece was done by Xi Peng Cai who was a graduating student from Minzu University of China (Beijing) in 2020. It is part of a series of similar paintings that depict young people focusing on their phones in what Marc Augé (2009) has referred to as 'non-places'—places of service in our postmodern societies.

Description of the piece: The style of the painting is figurative and expressionist (size unknown). The piece was done in oil painting, is multicoloured and includes, for example, flashy colours (pink, blue, yellow) to highlight the phone screens that the people are reading while walking up and down the stairs. In total there are about 20 young people, both male and female. It is hard to say if they are all Chinese or a mix of people from around the world. The vast majority seem to be wearing a COVID-19 mask which appears to have 'melted' onto their mouths. Some of the characters do not have a face at all. This is how the artist introduces the artwork to us (translated from simplified Chinese). She also asks us some questions related to the artwork:

My artistic creation focuses on individuals in society. How are individuals constructed by their social culture? What is the state of the individual surrounded by others in this work? In the COVID-19 era, masks have become an extra organ for people, and their thinking and behaviors have been disciplined by bio-politics under emergency conditions. Their faces are covered by masks and their eyes controlled by electronic devices. Where is the real face? How can communication be carried out without masks and/or mobile phones? How could human civilization move towards equal communication in such contexts?

We do encourage the reader to reflect on these questions too.

Problematizing re-encountering through the piece: Here again, in this piece, we face mis-encounters and *yet* re-encountering. Maybe some of these young people know each other and are walking with friends, family and/or colleagues. Maybe they are communicating with others on their phones and thus re-encountering them in a different space—that of online interaction. We recommend that you focus on any of these characters and decide for yourselves who they are, what they are doing there on the subway or in a mall and what they are doing on their phones. A couple of characters are not on their phones but looking sideways or some are faceless: *why are they there and what messages could they be sending to us about re-encountering?* Since this situation is common for billions of people in the world, being surrounded by 'bodies' and 'strangers' without them communicating or encountering is also a daily activity for most of us. Re-encountering here takes place for us, the viewers, too since many of us would have found themselves in a similar situation in a non-place somewhere in the world—we can re-encounter what appears to be mis-encountering here, dialoguing with our own past experiences. On rare occasions, when something eventful occurs in such situations, people might start talking to each other and (maybe) getting to know each other. In any city of the world, these invisible and yet common (intercultural) encounters are omnipresent, although there might be generational and socio-economic differences in the way they materialize. At times, they might be accompanied by swift stares, but usually no word is said and no verbal interaction. Following Michaux (2016), we might call both the situation depicted by the work of art and the representation of the characters as 'ghost-like'; *they are there, but they are not really there.* The re-encounter (since the situation is probably common to most of these 'moving' bodies) that is described is embedded in a complex network of

encounters, where faces, mirrors and multifaceted masks intervene [one final note: although most of the characters are focusing on their phone, they might be *staring* at someone online].

The last piece of this chapter was done by Fred and is entitled *Where are you from? II* (2022) (Fig. 3.3). This piece has to do with interculturality as 'international' and 'local' and focuses on 'interpersonal' encounters, 'face-to-face' [as a reminder, the two other pieces were about 'collective mis-re-encounters' within a family and amongst (some) strangers.]

Basic information about the piece: The piece was done on Canson paper and measures 29.7 × 21 cm. Japanese paint and gouache were used. The piece was included in an exhibition of Fred's artwork in China in 2022. The exhibition was entitled 万化之相 *KASVOT A Journey Through Ten Thousand Faces* and presented Fred's research work through art (Gallery: ICI LABAS). The topics of identity metamorphoses and (re-)encountering in interculturality were central in the exhibition.

Description of the piece: This is how Fred describes *Where are you from? II*:

> I drew this piece after an encounter in a park in China. As I was sitting on a bench reading, I realized that someone was about to take of picture of me – without asking for my permission. Somewhat destabilized by this experience, I asked them not to stare at and 'freeze' me through their camera. I then wondered about this episode: was this an encounter? Why would someone take a picture of me like that? What would they do with the picture? Who would see it and what would they make of me? What would this (unwanted) encounter and the future encounters of those viewing the picture later do to my identity? I drew the photographer half-hiding behind a curtain – that of their camera. My face is 'split' into two parts, since what the photographer saw in me probably has nothing to do with who I am as an individual with many identities and masks.

Problematizing re-encountering through the piece: Re-encountering is multifaceted here too, and the topic of mis-encountering is discussed by Fred in his description of the piece. In China and many other places, like many of us, Fred has experienced being stared at as a stranger and an outsider. He has himself, obviously, stared at many people in similar circumstances— therefore the situation also triggered a re-encounter with previous situations. While being stared at, Fred was staring at himself staring at others somehow. Taking a picture of a stranger is something that many of us will have also done, with or without asking for their permission. What the art

piece is trying to say, through, for example, the hypnotic gazes of both characters, is that re-encounters and mis-encounters should go beyond mere staring to allow us to enter into meaningful (intercultural) 'verbal' dialogues. Looking at each other from a distance—and without one of us being aware of the other's gaze when they take a picture of us furtively—is a form of intercultural gazing that can have, of course, an influence on us but that can also limit our engagement with self and other. The 'starer' is also 'stared at' and the 'staree' a 'starer'. In the art piece, the curtain (which symbolizes the camera used by the Chinese to picture Fred) belongs, in a sense, to both of them. No one is really peeking behind it, but everyone is.

[THINKING FURTHER]

1. Take a few pens, pencils and/or paint and try to produce your own versions of the three pieces of art from the chapter. Just use what you remember from them, especially in terms of re-encountering. Compare them to the originals. What do you notice? What aspect(s) of the encounters did you keep? What is missing? Why?

2. Looking at the three pieces of art, go through the four keywords of face, mask, mirror and language and explain to yourself how they can help you problematize mis-re-encountering for interculturality. Which of these concepts do you find the most useless/least interesting to observe the art pieces?

3. Summarize for yourself what re-encountering entails. What to do with the prefix re- for interculturality? What could we learn from engaging with the prefix?

4. A work of art is somehow always a 'snapshot' of a specific moment of encounters. Videos, installations and sculpture can add movement and change to artistic representations. The three pieces that we have looked at are 'static' somehow [although one could feel movement of the bodies in Fig. 3.2 or the changing power of staring in Fig. 3.3]. Now we would like you to imagine the next steps in the depicted encounters: what would the characters do? How would they (not) look at each other and consider each other? What would they say and think? What could be the future impact of the mirrors they represent for each other on themselves and their relations?

5. Finally, at the beginning of the chapter, we asked you to look around you for any artistic *re*-presentation of re-encountering (we can now add mis-encountering). Go back to these pieces at home and/or in public places, speculate and reflect further on what the artist is telling you about re-encountering (interculturally/or not).

Suggested Reading

Kapuscinski, R. (2008). *Travels with Herodotus*

This piece of literary reportage by the Polish journalist Ryszard Kapuściński documents his travels and encounters in Africa, China and India. Like the Greek historian Herodotus (who gave the book its name; around 400 BCE), each (re-)encounter with people, ideas, knowledges and events leads the author to look into the other's faces and masks—as well as his own—awakening his interests in the complexities of the places he visits. His re-encounters also dialogue with those of the Greek historian whom he consults while traveling. This book represents an important entry point into the topic of (intercultural) encounters and complements many of the discussions from this chapter.

Augé, M. (2009). *Non-places: Introduction to an Anthropology of Supermodernity*

In today's world, many of our mis-re-encounters take place in what anthropologist Marc Augé calls non-places—airports, train stations, malls, hotels, motorways but also mobile phones and TVs. These make encounters indirect, anonymous and, often, merely 'service oriented'. Interculturally, such non-places provide nexuses of similarities (we all have them!) that are worth exploring to problematize the ways we meet/mis-encounter each other in today's world. Moments of crisis in non-places can often lead to re-encountering 'for real', when we start talking to each other, looking at and considering each other beyond mere gazing.

Johnson, J. H. (2011). *Venice Incognito: Masks in the Serene Republic*

The chapter had the mask as one of its symbolic foci to discuss re-encountering. This book can help us unthink and rethink the varied

meanings and functions of 'masking'. For some of us, the Italian city of Venice is (maybe stereotypically) synonymous with being disguised and wearing a mask during, for example, the carnival. In this book, Johnson analyses how the mask has been used in early modern Venice by all kinds of people during and outside of the carnival season, for example, to 'twist' the strong social hierarchies of the city on the water.

Drolma, W. & Robison, B. (eds.) (2021). *The Other Face: Experiencing the Mask*

This edited book represents an important introduction to both *face* and *mask*. Robison is himself a mask maker and Drolma a fiction writer. In the book they have included different kinds of writings (e.g. fiction, essays, poetry) and art about the mask. The book is a great companion to continue reflecting on intercultural encounters through art.

References

Augé, M. (2009). *Non-places: Introduction to an Anthropology of Supermodernity: An Introduction to Supermodernity*. Verso.

Bakhtin, M. (1982). *The Dialogic Imagination: Four Essays*. University of Texas Press.

Brunner, D. D. (1998). *Between the Masks: Resisting the Politics of Essentialism*. Rowman & Littlefield.

Carson, C. (2021). *Robert Lepage's Intercultural Encounters*. Cambridge University Press.

Cho, J. M. (2022). *Sino-German Encounters and Entanglements: Transnational Politics and Culture, 1890–1950*. Palgrave Macmillan.

Christiansen, L. B., Galal, L. P., & Hvenegaard-Lassen, K. (2020). *Cultural Encounters as Intervention Practices*. Routledge.

COE. (2022a). *The Autobiography of Intercultural Encounters*. https://www.coe.int/en/web/autobiography-intercultural-encounters/home

COE. (2022b). *The Autobiography of Intercultural Encounters*. Module 3. https://www.coe.int/en/web/autobiography-intercultural-encounters/module-3-understandings-of-intercultural-encounter

Dahl, Ø. (2021). *Human Encounters: Introduction to Intercultural Communication*. Peter Lang.

Davidann, J., & Gilbert, M. J. (2019). *Cross-Cultural Encounters in Modern World History, 1453-Present*. Routledge.

Del Carmen Méndez García, M. (2016). Intercultural Reflection Through the *Autobiography of Intercultural Encounters*: Students' Accounts of Their Images of Alterity. *Language and Intercultural Communication, 17*(2), 90–117.

Dervin, F. (2016). *Interculturality in Education*. Palgrave Macmillan.

Dervin, F. (2022). *The Paradoxes of Interculturality: A Toolbox of Out-Of-The-Box Ideas for Intercultural Communication Education*. Routledge.

Dervin, F., Du, X., & Härkönen, A. (Eds.). (2019). *International Students in China: Education, Student Life and Intercultural Encounters*. Palgrave.

Drolma, W., & Robison, B. (Eds.). (2021). *The Other Face: Experiencing the Mask*. Bloss Plot Press.

Etymonline. (2022). Person. https://www.etymonline.com/word/person#etymonline_v_12750

Gammerl, B., Nielsen, P., & Pernau, M. (Eds.). (2019). *Encounters with Emotions: Negotiating Cultural Differences Since Early Modernity*. Berghahn Books.

Goffman, E. (2017). *Interaction Ritual: Essays in Face-to-Face Behavior*. Routledge.

Hawthorne, N. (2009). *The Scarlet Letter*. Dover Publications.

Helsinki.fi. (2022). Intercultural Encounters Master's Programme. https://www.helsinki.fi/en/degree-programmes/intercultural-encounters-masters-programme

Hsieh, E., & Kramer, E. M. (2021). *Rethinking Culture in Health Communication: Social Interactions as Intercultural Encounters*. Wiley-Blackwell.

Johnson, J. H. (2011). *Venice Incognito: Masks in the Serene Republic*. University of California Press.

Kafka, F. (1983). *Letters to Milena*. Penguin Books.

Kalopissi-Verti, S., & Foskolou, V. (2022). *Intercultural Encounters in medieval Greece After 1204: The Evidence of Art and Material Culture*. Brepols Publishers.

Kapuscinski, R. (2008). *Travels with Herodotus*. Penguin.

Kern, R., & Develotte, C. (2020). *Screens and Scenes: Multimodal Communication in Online Intercultural Encounters*. Routledge.

Levinas, E. (2017). *Entre Nous*. Bloomsbury.

Liu, Y., & Dervin, F. (2022). Racial Marker, Transnational Capital, and the Occidental Other: White Americans' Experiences of Whiteness on the Chinese Mainland. *Journal of Ethnic and Migration Studies, 48*(5), 1033–1050.

Markova, I., Linell, P., & Grossen, A. (2007). *Dialogue in Focus Groups: Exploring Socially Shared Knowledge*. Equinox.

Marotta, V. P. (2020). *Theories of the Stranger: Debates on Cosmopolitanism, Identity and Cross-Cultural Encounters*. Routledge.

Michaux, H. (2016). *Passages*. Gallimard.

Peng, R. Z., Zhu, C. G., & Wu, W. P. (2019). Visualizing the Knowledge Domain of Intercultural Competence Research: A Bibliometric Analysis. *International Journal of Intercultural Relations, 74*, 58–68.

Porto, M. (2019). Using the Council of Europe's Autobiographies to Develop Quality Education in the Foreign Language Classroom in Higher Education. *Language and Intercultural Communication, 19*(6), 520–540.

Ruest, C. (2020). The Autobiography of Intercultural Encounters: Mixed Results Amongst Canadian Adolescents. *Language and Intercultural Communication, 20*(1), 7–21.

Sharma, P. (2018). *Intercultural Service Encounters: Cross-cultural Interactions and Service Quality*. Palgrave Macmillan.

Song, X., & Sun, Y. (2019). *Transcultural Encounters in Knowledge Production and Consumption*. Springer.

Rethinking How We Meet Interculturally

Abstract After reflecting on identity and (re-)encountering, this chapter takes us through unthinking and rethinking how we meet interculturally. It aims to equip us with critical and reflexive ideas to move away and beyond some of the limited and limiting takes that we have been fed with through, for example, our economic-political locations, education, research, the media and previous encounters. The postcolonial/decolonial and the more than human are problematized and discussed as examples to help us decentre some of our takes on the notion. Intercultural philosophy is also introduced. All in all, the chapter calls for us to endeavour discovering and trying out new perspectives on interculturality *lifelong*. At the end of the chapter art pieces are used to reinforce our awareness of the need to unthink and rethink again and again.

Keywords Rethink • Unthink • Postcolonial • More than human • Intercultural philosophy

[THINKING FIT]

1. How often do you feel that the way you interpret what is happening to you *interculturally* cannot be explained through the belief systems and ideologies that you have been 'fed' with? Try to think of

F. Dervin, X. Tian, *Critical and Reflective Intercultural Communication Education*,
https://doi.org/10.1007/978-3-031-40780-2_4

concrete examples when you failed at explaining what was occurring because of the way you had been urged to think about interculturality.

2. Are you aware of alternative ways of understanding and explaining interculturality? From outside the dominating Western ideological landscape?

3. How much taking (non-)humans (animals, insects, objects, etc.) into account is part of your system of explaining and understanding interculturality?

4. Do you believe that art could help us grapple with interculturality in special and different ways away from current dominating research ideas on interculturality?

OUR INTERCULTURALITY IS NOT YOUR INTERCULTURALITY

In *Alice's Adventures in Wonderland* (Carroll, 1865: 76), we witness the following surreal conversation:

'Would you tell me, please, which way I ought to go from here?'
'That depends a good deal on where you want to get to.'
'I don't much care where…'
'Then it doesn't matter which way you go.'

This corresponds well somehow to our discussions of interculturality in this book. What the notion is ('where you want to get to') and what it entails ('which way I ought to go from here?') to people located in different parts of the world (and within the same geo-economic-political space) can differ immensely. The ways people engage with interculturality epistemologically (their knowledge positions), axiologically (in relation to their values) and ontologically (who they are) are influenced by many factors: conventions, values, practices, beliefs, ideologies passed onto them by education, broader society, marketing, media, family, friends and all kinds of different subgroups that people might belong to (temporarily). Their own experiences of interculturality might also push them to (co-)construct specific ways of explaining, understanding and engaging with others.

We note that these are all unstable and that they might change long and short term while leading people to 'perform' in certain ways temporarily. Dealing with interculturality can be 'done' in thousands of different ways. In this chapter we explore how to expand how we do it, bearing in mind the important reminder that (conceptually) 'our interculturality is not

necessarily your interculturality'—that is, although we might experience interculturality together, our ways of looking at it and experiencing might differ immensely, leading at times to misunderstandings, non-understandings, conflicts, feelings of superiority/inferiority and so on. Our pre-fabricated ways of examining how we do and experience interculturality tend to dominate our relations and (mis-)guide us in *becoming* with others—rather than being with, interculturality is always about change, transformation and metamorphoses as we have seen in earlier chapters. Foucault (1994: 45) tells us that 'there is always only one 'episteme' that defines the conditions of possibility of all knowledge, whether expressed in theory or silently invested in a practice'. Today, there is not just one 'episteme' that dominates intercultural thinking in research and education but several such epistemes, which we refer to as centrisms in this chapter. We'll discuss some of the alternatives that are currently being explored in different fields of research. This chapter proposes that art can also help us reflect on, explore, deepen and imagine news ways of engaging with interculturality.

Our working method here is influenced somehow by a psychological concept from Russian formalism: *ostranenie* (literally: making strange, see van den Oever, 2010). Theorists such as Victor Shklovsky (1990, Theory of Prose) suggest that art (in the broad sense of the word) should urge those experiencing it to live it as 'poetry', 'estrangement' and 'making the familiar unfamiliar' (*defamiliarizing*). In similar ways, when approaching interculturality, there is a need to 'fight' against our automatized perceptions and modes of interpretations. The other's experience and understanding of what we do together are bound to be different since they might look at it from different pre-fabricated ways.

This entails first and foremost questioning ourselves, our perceptions, our systems of thoughts and those who influence us. For Sophie Rogers-Gessert (in Drolma & Robison, 2021: 62): 'Questioning is the very thing which keeps ideas alive; they are perpetuated through reexamination and transmission'. She adds that questioning is a sine qua non to 'the process of adaptation to our ever-changing world' (in Drolma & Robison, 2021: 63). Change is central to interculturality as has been discussed before.

Before we review a certain number of (common and yet problematic) centrisms in the way we do interculturality, let us take a short break around a certain number of keywords that will be central in the next sections: *power, colonial (colony, decolonial), epistemology, nature* as well as *caring* and *togetherness*. First, we want you to reflect on these keywords for

yourselves. Why do you think that we are introducing them here? How do these words translate in the languages that you know? Are the translations 'obvious' and 'transparent' or do you struggle finding equivalents? Do you know anything about the etymology of these words that might inspire us to think further about the topics they represent? How do these terms connect to understanding interculturality 'otherwise'?

Power is now recognized as central in any social and knowledge relation and production and infuses everything from language use to identity symbols. A lot of research now focuses on this aspect of intercultural communication education in analysing both what people 'do' together interculturally and how scholars, educators and decision-makers 'dictate' knowledge about interculturality. For example, these books deal with both interpersonal relations and knowledge production:

1. Cho (2021). *Intercultural Communication in Interpreting: Power and Choices*
2. Boteva-Richter et al. (2021). *Political Philosophy from an Intercultural Perspective: Power Relations in a Global World*
3. Tian (2020). *Asymmetries in the Distribution of Power in the Multicultural Workplace: Reducing the Imbalances with Intercultural Competence*
4. Adams & DeLuzio (2012). *On the Borders of Love and Power: Families and Kinship in the Intercultural American Southwest*

The word power seems to have been introduced in the English language in the 1300s in relation to battle and legal matters and is based on a Latin word, which derives from Proto-Indo European for *powerful* and *lord*. Power as we understand it here could date back to the late fourteenth century. Thinkers like Michel Foucault (1926–1984) in the West—who one might label as postmodern and 'deconstructive'—have stimulated research on power over the past decades. It is important to bear in mind however that thinkers in different parts of the world and other times have also critically engaged with issues of power. We are thinking here of, for example, Gongsun Long (325–250 BCE) in China, a member of the so-called School of Name, who 'questioned everything'.

Our second key term is *colonial (colony, decolonial)*. This word dates back to the eighteenth century and refers to a country/district colonized by others. The word today has to do with 'European' ('Western') colonization from the past in different parts of the world and especially with the

process of decolonization from the twentieth century, post-World War II, which is somewhat still ongoing. The word colony comes from Latin for *settled land, farm* and is from *colere* for *to cultivate, to inhabit.* The Latin words find their origins in Proto-Indo European for *to revolve, move* and *sojourn.* Decolonial perspectives, urging us to think 'outside' and 'beyond' the West while recognizing the damage Western colonization has done (and is still doing somehow) to the rest of the world, now appear to be growing in importance in most of the human and social sciences. Although different subfields of intercultural communication education were somewhat slow (and reluctant?) to start these conversations, things are starting to change as we shall see later.

Decoloniality requires from us to rebel against what is often referred to as epistemic violence—that is, the imposition of dominating knowledge systems that do not accept alternatives and that do not listen to other ways of thinking about the human, the social and what we shall label as the posthuman in the next section. Epistemology is, in brief, the theory of knowledge. It aims to support us in reflecting on how we conceptualize, theorize and engage critically and reflexively with knowledge. In Ancient Greek, *episteme* referred to knowledge but also to skill and experience— *epi-* means *over, near* and *histasthai to stand,* from Proto-Indo European for *to stand, make* or *be firm.* Since the advent of 'Western modernity' around the eighteenth century (e.g. Maffesoli, 1997), specific ways of engaging with knowledge have dominated worlds of research and education: one must think, conceptualize, write and do research in certain ways to 'fit in' and get access to the global (Western dominated) epistemic realm of research. Again, current critiques of such trends might help us have access to other epistemic ways of engaging with interculturality (e.g. Aman, 2017; R'boul, 2022).

One of the elements to consider for examining interculturality afresh is what is often referred to as *nature* for many of us around the world. The dichotomy nature/culture has been influential over the past centuries. For the 'West', nature needs to be tamed and controlled by humans, and culture has to do with the Enlightenment, the Human taking over, dominating and creating by themselves. Before the modern era, the difference between these two was neither discussed nor considered. In many parts of the world, worldviews do not rely on the dichotomy, and 'nature' is considered as important as 'culture' or, in fact, embedded in each other (Descola, 2014). For etymonline.com (2022) the meaning of nature as 'the material world beyond human civilization or society; an original, wild,

undomesticated condition' is from the seventeenth century. Before that nature had to do with bodily processes and forces of the material world in English. We note that the word nature comes from Latin and Proto-Indo European words relating to *birth*. If there is such a thing called nature and separated from 'culture', then it should have to do with the origins of all, life, and cannot be placed in heterotopia—a 'non-place', a place of inexistence and separation—to borrow a concept from Foucault (1991).

To finish with keywords before problematizing the centrisms that blind us in front of the complexities of interculturality, let us explore words that urge us to open up our takes on the notion: *caring* and *togetherness*. These keywords have to do with why it is that we need to unthink and rethink the ways we examine, experience and interpret how we engage interculturally.

Care appears to be a central theme in some parts of the world, in research, education and politics. Caring for us and others consists in paying attention to respecting and empowering different ways of being together, listening to each other and contributing to each other feeling included, listened to and taken seriously while, as asserted earlier, questioning our own visions and ways of expressing them. Care in English is from many other linguistic sources such as Old high German for *complain* and *lament* based on a Proto-Indo European root for *cry out, call* or *scream*. The meanings and connotations of the word changed over the centuries to take on more positive flavours of being mindful of others. Caring in relation to interculturality is to not impose one's own ways of analysing what we do with others but to observe, hear and smell with others to try to come to a joint understanding of what it is that we do *together*.

About the idea of togetherness, a word that can be used interchangeably with community, collectivity, group but also, for example, integration, reciprocity and (maybe) unity, the very word *together* in English has to do with Proto-Germanic for *in a body* and Proto-Indo European to *unite, join* and *fit*. In China today, the word *together* is used in slogans for international and intercultural relations such as Together for a Shared Future (Yuan et al., 2022). The word can be translated in many ways: 团结 (regiment/corps + knot/node); 一起 (one + rise/up); and 一同 (one + same and with). *Unity, solidarity, rally* and *cohesion* are often proposed as translations for these words. Finally, in Finnish together is *yhdessä*, which can also translate as *at the same time, in the same place* and *in close association*. Interestingly both Chinese and Finnish include a direct reference to the number one (一 in Chinese, *yhd-* in Finnish).

We started this section with the blunt claim that (conceptually) 'our interculturality is not your interculturality'—even if we might experience it together. Our task here is not to make sure that they become aligned—this would be another illusion. Our interest is in raising a stronger awareness of this and to build up dialogues that can allow us to enrich our takes on interculturality, alone and/or together with others. In what follows, we consider some of the illusionary ideologies that 'pollute' our ways of thinking about interculturality and introduce 'alternative' and what we consider as enriching ideas. All the elements presented here can be re-problematized and re-imagined through art.

BECOMING AWARE OF 'OUR' CENTRISMS

Readers will be aware that the word *centrism* comes (obviously) from the idea of the centre (from Greek for *sharp point, goad* and even *sting of a wasp*). Centrisms consist of all the ideological positions that have been forced onto us (sometimes (wrongly) confirmed by our observations, encounters and experiences) and that place elements that form the core of aspects of our identity at the centre, often giving them a superior feel and position. Centrisms are hard to spot and especially to get rid of since they have often become naturalized, 'obvious' and 'taken for granted'. Identifying, building up awareness of and acting upon our own centrisms (and others for that matter) could enrich (unsatisfactorily) our takes on interculturality. In what follows we list and problematize some centrisms. These are mere examples based on our own observations and interests, and we encourage you to think of more such elements.

1. *Adult-centrism*: thinking of interculturality without taking into account the voices of, for example, children, teenagers and older folk, believing that they are 'intercultural dummies' whose conceptions on the intercultural are of no value.
2. *Anthropo-centrism*: placing the human at the centre of all belief, epistemic and value systems and disregarding the influence of other (non-)livings in intercultural encounters.
3. *Concept-centrism*: in-/directly we have been force fed with certain concepts and notions that have to do with interculturality and that we use without thinking too much. They can take over our views on interculturality and blind us in front of the realities of what we experience.

4. *Field-centrism*: as students, scholars and educators, we 'belong' to one or a few fields of knowledge, with their own accepted and often 'taken-for-granted' ideas and their 'gurus', who influence how we view interculturality (e.g. language education, teacher education, business studies).

5. *Ideology-centrism*: each take on interculturality, be it 'scientific' and/or 'public', has to do with ideological orders to do, think and act in specific ways. Our minds are full of such orders (guided often by economic-political agendas), which often blind us in front of other ways of discoursing and conceptualizing interculturality (e.g. *democracy-talk, diversity in unity, interculturality as a way of disseminating/'spreading' knowledge about self, Reconciliation*). Some ideologies are validated and legitimated as being 'better' and 'superior' to others, even in research on interculturality.

6. *Lingua-centrism*: using specific ways of speaking and 'flavouring' interculturality in English and other languages, assuming others share the same 'tang' of words (see R'boul & Dervin, 2023) and showing a complete lack of interest in the 'real' complexities of multilingualism in research and education (meanings, connotations, flavours, ideological cores, etc.).

7. *Times-centrism*: making assumptions about today's world compared to the past in terms of interculturality—as in 'the world has never been as diverse as today'—often privileging our times compared to the past.

Before we discuss how some current discussions of interculturality in different subfields of research have tried to provide ways of circumnavigating some of these centrisms, we would like you to reflect on how you experience yourself and together with others these centrisms. Review each of the centrisms and consider these questions:

1. What are the dominating positions in relation to these centrisms in the way you conceptualize and experience interculturality?
2. Is there anything that makes you feel uncomfortable in relation to the influence of these centrisms?
3. Has anyone ever made you notice that you were under the influence of specific centrisms?
4. How often do you realize that others fall 'victims' to certain centrisms?
5. Who and/or what seems to have inspired/imposed these centrisms onto you?

6. What alternative centrisms are you aware of in your own contexts and 'elsewhere'?
7. Can you 'counter' some of the centrisms that you have identified in your own way of thinking about interculturality, by, for example, finding alternatives?

ON THE NEED TO INCREASE OUR CHANCES OF MEETING 'OTHERWISE' AND BEYOND THE *ONLY* HUMAN

Is there a thought that would be worthy of not being thought again? (Canetti, 1989: 23)

In this section we explore some of the literature closely related to interculturality that represent steps towards new epistemic and ideological dimensions. The review is not systematic and is based on books that were published in English in recent years. We want the reader to 'collect' some current alternative ideas to reflect on interculturality through engaging with art in the final section of this chapter. The documents that were retained have to do with critical takes on how we could deal with interculturality beyond the 'accepted'. The review is limited here to works that have to do with (1) the post-/decolonial, (2) intercultural philosophy (which is embedded in the postcolonial but represents an interesting strand of unthinking and rethinking interculturality) and (3) the 'more than human' and ecology (sometimes referred to as 'the posthuman').

The Post-/Decolonial and Interculturality

To introduce the topics of 'postcolonial' and 'decolonial' in relation to intercultural communication education, we can think first of three volumes published in English in recent years:

1. *Reinventing Intercultural Education: A Metaphysical Manifest For Rethinking Cultural Diversity* by Dreamson (2016)
2. *Decolonising Intercultural Education: Colonial Differences, the Geopolitics of Knowledge, and Inter-epistemic Dialogue* by Robert Aman (2017) from the broad field of international and comparative education
3. *Postcolonial Turn and Geopolitical Uncertainty: Transnational Critical Intercultural Communication Pedagogy* edited by Atay and Chen (2020) in the field of intercultural communication education

While Aman uses the action of decolonizing and Atay et al. hint at a post-colonial turn, Dreamson positions his work within metaphysics (which is also a postcolonial stance in the book). In his book Aman (2017) is critical of interculturalists in education for using an essentially Western framework of knowledge, ignoring the myriad of epistemologies available in different corners of the world. Focusing on the concept of *interculturalidad* as used in Latin America, the author offers what he refers to as an inter-epistemology of interculturality, beyond Eurocentrism. Atay and Chen (2020) problematize the *critical* in critical intercultural communication through the lenses of postcoloniality and globality, focusing on some of the issues that were discussed earlier: power, voice and the importance of considering geopolitical stances. Decolonizing intercultural communication pedagogy for the authors then aims to contribute to global social justice and change. In *Reinventing Intercultural Education: A Metaphysical Manifest for Rethinking Cultural Diversity*, Dreamson (2016) proposes an intercultural valuism pedagogy for teachers beyond mere 'Western' pre-suppositions, introducing readers to non-Western cultural/religious concepts, narratives and doctrines such as *Aboriginal Dreaming, Buddhist Sunyata, Taoist Yin and Yang* and *Islamic Tawhid*. The aim of this peda-gogy is to reflect on the intercultural characteristics of such elements when considered through the lens of value networks.

Many other subfields of research related to interculturality also discuss postcoloniality and decoloniality—sometimes in their own terms. Close to the topic of our book, *Intercultural Aesthetics: A Worldview Perspective* edited by van den Braembussche et al. (2010) calls for the recognition of artistic (intercultural) cross-fertilization aesthetically speaking, inspired by interactions between 'Western' and 'non-Western' philosophies (see below). In the field of science and technology studies, Reyes-Galindo and Ribeiro Duarte (eds.) (2017) focus on interactions between different actors involved in research (scientists, communities, policy-makers, the public, etc.) across the world. This important book takes on a global per-spective on these issues by including many chapters from the Global South where postcolonial struggles in communication science are problematized interculturally. The broad field of international relations (IR) has also con-tributed new knowledge about interculturality, opening us new vistas for postcolonial thinking. Boteva-Richter et al.'s (eds.) (2021) *Political Philosophy from an Intercultural Perspective: Power Relations in a Global World* opens up discussions about power relations in the world related to, for example, global poverty and experiences of injustice, by involving

non-European philosophies from different regions of the world in order to decentre the way these issues are dealt with and problematized today. Two other books of interest in the same field introduce and trace the thoughts and theories of thinkers from the Global South: *Postcolonial Constructivism:* [Ali] *Mazrui's Theory of Intercultural Relations* (Adem, 2021) and *Kautilya and Non-Western IR Theory* (Shani, 2018) about an ancient Indian text called Arthaśāstra. Both contribute 'non-Western' and 'beyond Eurocentrism' resources for expanding our thinking in terms of international and intercultural relations. They encourage us to explore lesser-known epistemic takes on these issues to enrich our own views and experiences of interculturality, making them more 'global' than 'Western global'.

Learning with Intercultural Philosophy

It might sound a bit artificial to 'separate' the decolonial/postcolonial and intercultural philosophy, an international attempt to include global philosophical voices beyond 'Westerncentric' perspectives, since both aim for the same objectives. However, we feel that intercultural philosophy has made some original and inspiring contributions to interculturality that deserve to be highlighted. We note at the beginning that it is not a 'unified' field as such and that many (unofficial) branches seem to exist, in both the Global North and Global South—although they might label what they do differently.

A good introductory volume on 'Comparative and Intercultural Philosophy' is Ma and van Brakel's (2017) *Fundamentals.* The authors problematize interpreting, comparing and discussing different forms of philosophical practices from different parts of the world (especially 'China' and 'the West'), focusing on how to speak of similarities and differences. *Philosophies of Place: An Intercultural Conversation* edited by Hershock and Ames (2022) tackles the topic of *spaces* transformed into (more personal) *places*, impacting on people's identities, from Asian, European and North American traditions of thought interculturally. The chapter authors also problematize the connections of, for example, politics and religion/worldviews in these different epistemic takes on a special entry into interculturality. Gift and the common good are the intercultural focus of a book edited by Schweidler and Klose (2020) where the following questions are discussed from multifaceted perspectives: 'What are we living for? What are we working toward? What holds us together?' The original issue

of the intercultural economy of the gift is also at the centre of the book discussions.

Phenomenology seems to be an important 'intercultural' approach in the field. In *Phenomenology and Intercultural Understanding: Toward a New Cultural Flesh* by Lau (2017), readings of different philosophies from the Global South such as Buddhism and Daoism are proposed to discuss intercultural understanding. These also allow a critique of Eurocentrism in global philosophy, which is inspiring for anyone working on intercultural communication education. In a similar vein, Graneß et al.'s (2022) *African Philosophy in an Intercultural Perspective* and Berger's (2021) *Indian and Intercultural Philosophy: Personhood, Consciousness, and Causality* urge us to interrogate the project of intercultural philosophy from African and Indian philosophical traditions, placing them in conversations with traditions from other parts of the world— beyond the mere 'West'.

The notion of Ubuntu has been extensively discussed in different fields of research in recent years, especially in religious and cultural studies and intercultural philosophy. We note that the distinction between philosophy and religion outside the 'Western' world is complex and not as clear-cut as in, for example, the European context. In *Understanding Ubuntu for Enhancing Intercultural Communications*, Mukuni and Tlou (2021) deal with harmony and interpersonal relations beyond 'Western' models of interculturality, placing the Ubuntu indigenous philosophy at the centre. Ubuntu lays the emphasis on maintaining good relations, sensitivity to the well-being of others as well as collectivities over individualism. Mukuni and Tlou argue that Ubuntu can serve as an original contribution to interculturality by focusing on, for example, teamwork and respect for diversity of opinions.

Finally, many publications focus on the specific work of intercultural philosophers, highlighting what they have contributed to unthink and rethink interculturality, beyond the West. Schepen (2022) details the work of Heinz Kimmerle (1930–2016) and his 'ongoing quest for epistemic justice' in relation to African philosophies; van Binsbergen (2021) presents his own engagement with intercultural philosophy through the discovery of what he calls 'African spiritualities'; Dübgen and Skupien (2018) introduce African intellectual Paulin J. Hountondji's philosophical arguments within a postcolonial framework.

The More than Human and Ecology

Let us introduce this subsection with a short excerpt from writer Herman Hesse's (2022: 27) *Trees: An Anthology of Writings and Paintings*:

> When a tree is cut down and reveals its naked death-wound to the sun, one can read its whole history in the luminous, inscribed disk of its trunk: in the rings of its years, its scars, all the struggle, all the suffering, all the sickness, all the happiness and prosperity stand truly written, the narrow years and the luxurious years, the attacks withstood, the storms endured. (…) Trees are sanctuaries. Whoever knows how to speak to them, whoever knows how to listen to them, can learn the truth. They do not preach learning and precepts, they preach, undeterred by particulars, the ancient law of life. (…) Trees have long thoughts, long-breathing and restful, just as they have longer lives than ours. They are wiser than we are, as long as we do not listen to them. But when we have learned how to listen to trees, then the brevity and the quickness and the childlike hastiness of our thoughts achieve an incomparable joy.

What Hesse reminds us here is that trees ('nature' to put it in a simplistic way) are with us and are part of us; they constitute our history, our air, our teachers, our mirrors and so on. This last subsection has to do with what we refer to as the 'more than human', other livings and non-livings that are with us and that communicate with us and through which we interact and experience relations, lives and so on. Like in many other fields of research in the social and human sciences, interculturality is often treated outside the realm of the more than human (see Dervin & Yuan, 2022). However, for Mengozzi (2021: 14) 'not only is this world composed mostly of "not-us" (animals, plants, bacteria, microbes, not to mention the inanimate world) but also the frontier between us and "not-us" is becoming more and more porous'.

In one of our contexts, China, the presence of other livings and non-livings—like in most societies—is obvious. We look around and we see a lot of hybrid creatures, for example, at the entrance of many buildings (see Fig. 4.1), service robots (some looking like humans), figurines of all shapes and colours, but also pets, animals and insects—we could add objects, infrastructures and the broad term of the environment. The presence of these more than human does influence the way we are with others, what we say and do and the identities we project and create with them. The lack of care for other livings and non-livings also hints back at issues of

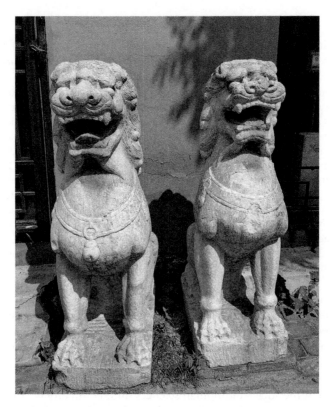

Fig. 4.1 Hybrids found in front of a home in China

coloniality. As such and in line with the previous subsections, hooks (2009: 132) maintains that 'We must all decolonize our minds in Western culture to be able to think differently about nature, about the destruction humans cause'. Following Spivak's (2002) counter-focalization, we should re-imagine and re-read interculturality not just from humans' viewpoints but also from the perspectives of other livings and non-livings. In a remarkable example beyond anthropocentric arrogance entitled *A Giraffe's Journey to France (1826–1827): Recording the Encounter from the Animal's Point of View*, Baratay (2021) retells the experience of the first giraffe (i.e. a giraffe-centric account) to be toured around France in the nineteenth century, emphasizing the intercultural confrontations that it represented between two worlds. The author highlights the giraffe's fears, misunderstandings,

passions as well as the intercultural tensions experienced with people around it in France. Commenting on Baratay's work, Mengozzi writes (2021: 15): 'if we assume that animals are not poor- but rich-in-world, that their silence is not the sign of deprivation but littered with traces, postures, movements, perceptions, cries, squeaks, affections, and abilities, and if we acknowledge that they might see, feel, and touch something that eludes us, then we must also admit that confining ourselves to the human side of things—without even trying to translate into human language those non-human lives and worlds—means precluding the opportunity to escape "from our spiritual narrowness"'.

The more than human has also been problematized as, for example, the posthuman or the post-anthropocentric (see above) by Rosi Braidotti (2013). The thinker also urges us to consider the extensive web of complex interrelations between us and other livings (animals, insects, plants, etc.) and non-livings and to challenge 'the centrality of anthropos' (Braidotti, 2013).

A few books have tried to help us think the place of the more than human and ecology in relation to interculturality. In what follows we introduce a selection of writings which we suggest exploring.

1. Hashas' (2017) *Intercultural Geopoetics in Kenneth White's Open World* details what it is that we could learn from the Scottish poet, writer and academic Kenneth White's work in relation to the earth, nature and self. We find White's geopoetics, through which he celebrates the re-enchantment of the world, to be creatively interesting to deepen our diverse engagement with interculturality.

2. In a book already published over a decade ago, Ip (2009) and the chapter authors show how different perspectives such as Buddhism, Christianity, Daoism and Islam can support us in reflecting ethically about protecting the environment. In a similar vein, *Walking with the Earth: Intercultural Perspectives on Ethics of Ecological Caring* (Haaz & Ekué, 2022) presents the views of authors from four different continents about the ethics of working *together with* nature (understood in a broad sense).

3. Indigenous approaches are also beneficial to expand our understanding of interculturality beyond the human. Williams et al. (2012) propose a radical human ecology perspective by exploring indigenous and traditional peoples' epistemologies that can enrich our ideological takes on interculturality.

4. *Narratives for Nature: Storytelling as a Vehicle for Improving the Intercultural Dialogue on Environmental Conservation in Cameroon* (Zwaal, 2008) informs us of how local people might perceive and put into words specific perceptions of the more than human in comparison to the discourses of 'Western' environmentalists. Using the technique of storytelling the proposed 'posthuman' approach urges us to listen to local voices and to engage in discussions of potentially better and more sustainable solutions.

5. It is also important to remember here that anthropology, as a field that has centred around the intercultural (without naming it as such, see Lavanchy et al., 2011), has also contributed new thinking around meeting others by reflecting on the influence of other (non-)livings. This is the case of *Outside the Anthropological Machine: Crossing the Human-Animal Divide and Other Exit Strategy* edited by Mengozzi (2021). The anthropological machine is the range of 'blinded' perspectives used in anthropology since its emergence that ignore the importance of, for example, animals in our lives. The chapter authors urge us to relate to companion species as a way of moving away from anthropocentrism.

In the previous subsection, we listed the following centrisms as 'blindfolds' that need to be addressed constantly (and urgently) by all of us to re-engage with interculturality: *adult-centrism, anthropo-centrism, concept-centrism, field-centrism, ideology-centrism, lingua-centrism* and *times-centrism*. This subsection has provided us with 'seeds' of alternative knowledge to unthink, revise and rethink (ad infinitum) these centrisms. Postcolonial and decolonial perspectives, intercultural philosophy and reflections around the more than human can help us turn these centrisms around, considering views, beliefs and epistemologies from other parts of the world, learning with and through interdisciplinarity (beyond our often 'limited' field), taking into account various (non-)livings in our analyses of interculturality and speaking about what we do in other (temporary) ways. These, again, are only snapshots of what is available out there in the big (real) global worlds of research. We must endeavour to continue without any end in sight to explore, 'dig' into and unearth, combine (and at times discard) ideas, methods, arguments, ideologies and so on. In the next section, we take what we have gotten from this chapter hitherto and reflect further on the contribution that art can make for interculturality.

REFLECTING AFRESH ON INTERCULTURALITY IN AND THROUGH ART

Our goal in this chapter is to support ourselves to move beyond 'calcifying' our take on interculturality so we can engage with and around it in different ways. We have discussed different ways of thinking beyond and further. In what follows, we suggest letting our imagination take over and consider some of the issues discussed above through art.

But before we look at three pieces of art, let's listen to a conversation between Zhuangzi and his friend Huizi. *The Zhuangzi* (庄子), a classic of philosophical Daoism, dates back to the Warring States in Chinese history (350–250 BCE). In a chapter entitled 'Enjoyment in Untroubled Ease' (逍遥游, Zhuangzi, 2022: n.p.), Zhuangzi and Huizi hold the following conversation around gourds (calabashes in the excerpt) that Huizi had planted:

Huizi told Zhuangzi, saying,
'The king of Wei sent me some seeds of a large calabash, which I sowed. The fruit, when fully grown, could contain five piculs (of anything). I used it to contain water, but it was so heavy that I could not lift it by myself. I cut it in two to make the parts into drinking vessels; but the dried shells were too wide and unstable and would not hold (the liquor); nothing but large useless things! Because of their uselessness I knocked them to pieces.'

Zhuangzi replied,
'You were indeed stupid, my master, in the use of what was large. There was a man of Song who was skilful at making a salve which kept the hands from getting chapped; and (his family) for generations had made the bleaching of cocoon-silk their business. A stranger heard of it, and proposed to buy the art of the preparation for a hundred ounces of silver. The kindred all came together, and considered the proposal. "We have," said they, "been bleaching cocoon-silk for generations, and have only gained a little money. Now in one morning we can sell to this man our art for a hundred ounces - let him have it." The stranger accordingly got it and went away with it to give counsel to the king of Wu, who was then engaged in hostilities with Yue. The king gave him the command of his fleet, and in the winter he had an engagement with that of Yue, on which he inflicted a great defeat, and was invested with a portion of territory taken from Yue. The keeping the hands from getting chapped was the same in both cases; but in the one case it led to the investiture (of the possessor of the salve), and in the other it had only enabled its owners to continue their bleaching. The difference of result was

owing to the different use made of the art. Now you, Sir, had calabashes large enough to hold five piculs; why did you not think of making large bottle-gourds of them, by means of which you could have floated over rivers and lakes, instead of giving yourself the sorrow of finding that they were useless for holding anything. Your mind, my master, would seem to have been closed against all intelligence!'

In this short narrative Huizi can only think of using the gourds for one specific purpose (drinking water), but he fails to think of other potential uses of the calabash, for example, as a floater. His worldviews, beliefs and conceptualizations seem to have closed his mind in front of other opportunities, as Zhuangzi rightly reminds him. Often, our experiences of interculturality or the ideologies that have been passed onto us operate the same way and make us close our eyes in front of the hundreds of possibilities of unthinking and rethinking the notion.

Three art pieces are discussed below. First, we shall reflect around a 'diptych' composed of two separate and yet related art pieces by Tianque Ding 丁天缺 (1916–2013). The pieces share the same context and topic and are entitled *Tiger Leaping Gorge, Yunnan* (1980) and *Life* (1999). *Genie in the woods* (2016) was painted by Fu Aimin 付爱民 who is from the Chinese Xibo Minzu 'ethnic' group from the Yunnan Province (Southwest China). The third piece from 2022 was done by Fred and is entitled *La nature et moi* (Nature and I).

Before we review each piece reflect on the following general questions:

1. How often do you pay attention to other livings and non-livings in different kinds of art? Review your favourite pieces of art and pay particular attention to their presence and how much they 'talk' to you.
2. Do you find art *around you* to be generally speaking anthropocentric? Is this a problem?
3. How aware are you of art from other contexts, especially art that could be labelled as *postcolonial*, see *decolonial*? If you are not aware of this important type of art, do an online search to review what some of the pieces look like and the topics they cover.
4. Do you clearly see different systems of thought (religion and philosophy included) having influenced artists in their work? In other words, for the artists whom you know and/or are aware of, can you tell in their style, themes, use of colours and so on, how much certain views and beliefs have influenced their work? Check, for exam-

ple, the work of artists such as Marc Chagall or Gerard Garouste who were highly influenced by their Jewish identity.

We are going to review three (in fact four but two serving as a diptych) artworks in what follows. Before reading what we want to share about them in relation to unthinking and rethinking interculturality, pay attention to the pieces and consider these extra questions:

1. What kinds of atmospheres do you 'feel' while engaging with the pieces?
2. What are the artists trying to tell us about identity, diversity, interculturality and life? Could you try to imagine their voices?
3. How do they take into account the more than human in conveying their messages?
4. How do the three pieces compare in helping us unthink and rethink the ways we 'do' interculturality?
5. What extra layers of meanings do the colours and forms provide?
6. Can these pieces teach you anything about interculturality 'otherwise'?
7. Do these pieces remind you of other artworks that you might have come across in your context(s), elsewhere and/or online? What kind of intertextuality in terms of the five senses (sight, smell, touch, etc.) do you feel?

Tianque Ding 丁天缺: *Tiger Leaping Gorge, Yunnan* (1980) and *Life* (1999)

The first time we came across the work of Tianque Ding (1916–2013) was at an international art gallery in Beijing. We met the artist's niece, Ding Yunqiu (Ting Wan Chow), at ICI LABAS gallery located at the famous art district called 798, of which she is the owner. During the visit, we were taken through a retrospective of Ding's art and were particularly impressed by the two pieces discussed here (see Fig. 4.2). Tianque Ding studied art with internationally recognized artists from China such as Wu Guanzhong (1919–2010) and Zao Wou-Ki (1920–2013) in Hangzhou (Eastern China). They all shared the same interest in both Eastern and Western artistic traditions. Because of his political beliefs, however, Ding was arrested in 1951, spent time in jail and was later sent to the countryside for his 're-education'. He started his art activities again at the end of the 1970s when he was rehabilitated (Ding, 2021). During his studies with

Fig. 4.2 'Diptych' (Ding Tianque, 1980–1999)

Wu Dayu (1903–1988), who was one of the first Chinese artists to have studied in France, he was inspired by what the master told him (Ding, 2021: 152): 'your colours must have a soul and your brushstrokes a life' (our translation).

During the aforementioned retrospective, we were touched by a 'diptych' of two of Ding's paintings, which were installed side by side: *Tiger Leaping Gorge, Yunnan* (1980) and *Life* (1999). These artworks 'spoke' to us in relation to interculturality and identity through both the symbolism of the forms and use of colours. The pieces are both oil on canvas and measure, respectively, 84 × 63.5 cm and 92 × 73 cm. Painted with a time difference of nearly 20 years, the pieces use the same dramatic background as a topic—a gorge in the Yunnan Province of China (southwest). Tiger Leaping Gorge (虎跳峡 in Chinese) is one of the deepest in the world with an altitude of about 1800 metres, with two famous mountains on each side (Jade Dragon Snow Mountain and Haba Snow Mountain). The gorge is part of the UNESCO site called Three Parallel of Yunnan Protected Areas. When the first art piece was produced, Ding was 64, and he had just regained the 'freedom' to work on his artistic production again. The second piece was finished when Ding was 83—a decade before he passed away.

In the 'diptych', Ding represents and morphs different 'human beings' into the mountains using the famous Gorge as a range of characters. In the

1999 piece (on the left of Fig. 4.2) the shapes are somehow harsh, geometrically 'square' and gloomy. The faces represented by the mountains look old, severe, exhausted and full of pain as if they were begging for help or even giving up. The colours are also somewhat dark, with the river looking sombre and dirty. The faces seem to be staring at each other and/ or at the desolate state of the river. Although one can feel tensions and disharmony, the faces carved into the landscape seem to come together to share what could be perceived as grief, hopelessness and despair. Figure 4.2 may not be of quality good enough for our readers to notice that on the right side of the river, just in front of the anthropomorphic mountains, one can see a small human figure struggling with the river current, trying to avoid crashing against the large rocks placed in the middle of the river on the right. When Ding painted this first piece, he had just emerged from many decades in detention and hard labour in China. Life was difficult for him. He had missed on creating art for decades; he had an unstimulating job, and he was unmarried—nothing to look forward to. The famous landscape is a reminder of his bleak conditions; the landscape becomes his conditions; the landscape dialogues with his conditions. The second piece painted nearly two decades later at an advanced age presents completely different 'flavours'. The anthropomorphic mountains have 'smoothened', and the figures appear mature and comfortable with themselves. Unlike the first one, they are not staring at each other—Complaining to each other? Cursing at each other? Being aggressive to each other?—but taking the environment into account by looking in different directions. Their shapes are round, depicting nice non-threatening landscapes. The colours have also changed. The river now looks 'healthier' with different tints of blue and currents that appear less threatening, rounder and full of life. The sky is also of a light blue (compare to the 1980 piece). A decade before his death, Ding felt at peace with himself and his environment. Things had changed in Chinese society. Although his past was still *in him*, he made peace with it. Look at the character boating down the river in this second artwork: they seem to feel more comfortable, turned towards the big rocks in the middle of the river, with the confidence that they are not going to crash against them. Ding had been able to paint again for some time; people were interested in his work, and he had gotten married. By portraying the same landscape but with different tones, feelings, identity projections, ideas, experiences and messages, Ding represents the movement of life, the transformations that we all go through in life. Although here 1980 and 1999 seem to shift from the 'bad' to the 'good'—which could

be seen as simplistic—one can take the 'diptych' in whichever order one wishes to reflect on the unpredictabilities of life.

Looking at the two pieces we are reminded of a saying in Chinese concerning Mount Lushan, 不识庐山真真面目, 只缘身在此山中, which can translate as *you can't see the true appearance of Mount Lushan because you are in it*. What this saying reminds us is to look at things from different perspectives and to take other elements into account when reflecting on ourselves, others, the world and life. The way we see something might be different depending on where we stand, which side, with whom and for what reasons/purposes. Ding asks the same from us: the anthropomorphism of his pieces reminds us that our broader ecology does communicate with us, corresponds to us and influences us in the ways we behave, identify and are with others. Beside the anthropomorphic figures, the small person boating through the river is also a typical reminder in Chinese art (see below) that our human condition is 'microscopic' in relation to 'nature'. The mountains take over somehow in the pieces; they dominate the piece of art; they become us humans (or we become them?). Instead of us dictating what 'nature' feels like, in the pieces, 'nature' shares their emotions and relations to life and the world. Interculturality in the 'diptych' is multifaceted: between nature and the human (conflicts, symbiosis, power relations), between *re*-presented humans (power relations, shared/forced emotions), between 'nature' and 'nature' (different elements threatening each other) and between different life experiences (harsh times, quieter ones).

Fu Aimin 付爱民*'s* Genies in the Woods *(2016)*

This second art piece has a different feel compared to the previous 'diptych'. The piece (82 × 88 cm) depicts two young girls bathing in a river. The girls belong to the Dai Minzu 'ethnic' group of China, a group based in the Yunnan Province of the country (Southwest). The artist, Fu Aimin (born in 1972), is a professor of art at Minzu University of China (Beijing). He is himself of the Xibo Minzu identity, another Chinese 'ethnic' group located in the Yunnan Province. His father is of another Minzu group: the Manchus. As a scholar he specializes in Minzu 'ethnic' art and ecological cultural industry, with an expertise in ecotourism. In both his research and art, he has explored different Minzu 'ethnic minorities' from Yunnan such as the Lahu, Wa and Dai groups. *Genies in the woods* is part of a larger project of Dai female bathers (more than 20 pieces), through which the

artist aims to share customs and scenes of specific Minzu 'ethnic' groups. The artist has spent a lot of time in Minzu villages in Yunnan observing what local Dai people do. He would often go to the river to take pictures of the scene as inspiration for his artwork. Using a special painting technique from Japan, the artist wanted to share the kind of special lights, water reflections and shadows that one can see in places like the one where the girls are bathing. He notes in his explanations to us that 'this is not like a photography (…) I am borrowing the feeling of that time, painting the most natural and comfortable feeling of people through shifts in the colours'. Like Ding's piece, 'nature' also becomes anthropomorphic; it becomes us when one observes how shapes and shadows produced by the trees, leaves and water merge with the two characters (Fig. 4.3).

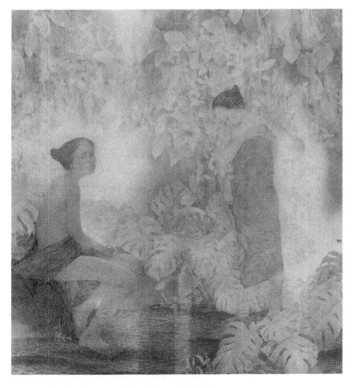

Fig. 4.3 *Genies in the woods* (Fu Aimin, 2016)

Like Ding's pieces the role of nature seems to be essential here. It is hard to say what 'comfortable' means in the words of the artist in the previous quote, since this can be very polysemic. For some of us, we might feel uncomfortable in front of this moment of intimacy (bathing in a river). And it might also be difficult to interpret the feelings of the girls in the painting—one seems to be hiding and looking somehow shy, while the other is looking in our direction, 'feeling-less' or, perhaps, blasé. Some of the viewers might be reminded of orientalist and culturalist art in front of *Genies in woods*. They might even link it up to 'exotic' pieces by Paul Gaugin (1848–1903) about Haiti, where he used what we could refer to as a 'primitive' depiction of spiritual and emotional states. There could be some intertextuality with what the 'West' would refer to as postcolonialism, depictions of the other (essentialism) as the (ideal) 'happy savage' and/or even cultural appropriation here too. How much such an analysis fits in with the Chinese Minzu context is a difficult question since the piece was done by an artist who is himself from a Minzu 'minority' group. So, interculturality here can also be viewed through different lenses: an artist from a minority group re-presenting other minority groups; the use of a Japanese artistic technique to translate the specific (perceived) atmosphere of the scene; a range of potentially 'imported' (and misleading) reading lenses (e.g. decolonial, exoticism, the 'savage') to make sense of the piece; different emotional struggles to examine what the characters feel in front of the artist's gaze (and thus ours); and the intertextuality of similar pieces painted with (different) motivations, states of mind and encounters and in different times and spaces (see the aforementioned Gaugin reference), leading us to interpret the piece in different and often 'displaced' ways (power relations, culturalism, essentialism, etc.).

Fred Dervin's (2022) *La Nature et Moi I*

The final art piece was by produced by Fred for his 2022–2023 exhibition in Beijing. The title is French and means *Nature and I*. The piece was included in the third section of his exhibition which problematized identity transformations, re-encountering and between nature and us. Like this chapter the third section of the exhibition was meant to support the viewers to open up their understanding of self, other, the hyphen between them and the world by taking the more than human into account. The piece is the smallest of the art pieces presented here (27.6 × 18 cm). This is how Fred presents Nature and I:

The very last series of works focuses on representing self and nature, especially mountains. Mountains are not very common sights in Finland since the country tends to be rather 'flat'. In a place like Beijing, there are many mountains surrounding the city. I have always been amazed by mountains. They remind us how small we are as beings – they even put us back in our 'small' place! I have noticed how, in Chinese art, mountains are usually depicted as dominating a landscape, with people given a very small part to play in the artworks. The piece shows how I relate to white, black and colourful mountains. However, the character that I have placed in front of them, although somewhat smaller than the mountains, still seems to dominate the landscapes. What do the mountains tell about the character? How complementary is the character and nature here?

Figure 4.4 shows a range of mountains that dominate most of the piece with its white and black embryonic forms. Such mountain landscapes are

Fig. 4.4 *La nature et moi I* (Dervin, 2022)

not found everywhere around the globe, although one might see them in many countries and continents. For anyone who has never seen mountains, the feeling that they inspire might be awe-inspiring, towering over us 'small humans'. Here the mountains, like Ding's 1999 piece, appear to be rounded, somewhat maternal-like—pleasant to the eye in any case, neither threatening nor suffocating. In front of the mountains, there is a character who appears to be 'two-faced', one of their eyes is opened, looking above us (while being somewhat inquisitive), and the other eye is closed as if in a sleeping mode. *Is it a woman or a man? Is s/he young and/or older? Who is s/he? Where is s/he from? Why is s/he there?* [does it really matter?]. Flashy pink and yellow spots 'decorate' their cheeks, while the shape of their face is very much reminiscent of the shapes and forms of the mountains.

In the end, although their face represents an important focus point in the art piece, 'nature' through the image of the mountains takes over and 'cooperates' with the character in trying to communicate a message to us. What the message is about is hard to decipher. However, one could easily imagine that both mountains and the character are asking us to bear them both in mind, remembering that they are both part of each other and, at the same time, part of us all.

[THINKING FURTHER]

1. Take your drawing and painting material and try to create a piece illustrating the main messages of this chapter. You can also try to combine different ideas and elements from the four art pieces from the chapter.

2. Try to recall your experience of seeing a piece of art re-presenting people from other countries, continents and cultures that made you feel uncomfortable. Can you remember why? What was it about the piece that created these feelings? Think of the colours, shapes, themes, ideologies, characters and so on.

3. Looking at the different environments depicted in the art pieces, try to imagine for yourself how it would be for you to get to meet someone surrounded by, for example, the mountains and or the rivers that they contain. How would these influence the way you interact with others?

4. Finally, reflect on this question: can art help us see the way we do and conceptualize interculturality 'otherwise', in relation to the postcolonial and the more than human?

Suggested Reading

Leuthhold, S. (2010). *Cross-Cultural Issues in Art: Frames for Understanding*

Focused on issues of aesthetics, this important interdisciplinary book moves beyond 'Western' theories of art by introducing elements from Africa, Asia, Europe, Latin America, the Middle East and Native American art. Many issues covered in our book such as (in alphabetical order) colonialism, ethnicity, nationalism, otherness, power and religion are discussed.

Janer, Z. (2022). *The Coloniality of Modern Taste: A Critique of Gastronomic Thought*

This book represents an original entry point into decoloniality and post-colonialism. Its focus is on the coloniality of gastronomy, problematizing issues of colonial and capitalist structures, racialization and desensualization. Like art, gastronomy can help us re-imagine the way we engage with something as 'simple' as food.

Dervin, F. & Yuan, M. (2022). *Reflecting on and with the 'More-than-Human' in Education: Things for Interculturality*

In this book, the central aspect of the more than human is problematized for interculturality. The authors explain how the presence and influence of things are entangled with the way we experience, do and reflect on interculturality. They urge us to open our eyes to the richness that the more than human for interculturality represents for us all.

Milstein, T. & Castro-Sotomayor, J. (2022). *Routledge Handbook of Ecocultural Identity*

This handbook was published as part of environment and sustainability handbooks. It tackles the stimulating notion of ecocultural identity whereby the ecological and the sociocultural are problematized together in relation to self and other. Essential topics such as the creation of environmental conviviality through difference and spaces of interaction and the enmeshment of the political sphere and ecological forces are dealt with.

REFERENCES

Adams, D. W., & DeLuzio, C. (2012). *On the Borders of Love and Power: Families and Kinship in the Intercultural American Southwest*. University of California Press.

Adem, S. (2021). *Postcolonial Constructivism: Mazrui's Theory of Intercultural Relations*. Palgrave Macmillan.

Aman, R. (2017). *Decolonising Intercultural Education: Colonial Differences, the Geopolitics of Knowledge, and Inter-epistemic Dialogue*. Routledge.

Atay, A., & Chen, Y.-C. (Eds.). (2020). *Postcolonial Turn and Geopolitical Uncertainty: Transnational Critical Intercultural Communication Pedagogy*. Lexington Books.

Baratay, E. (2021). A giraffe's Journey to France (1826–1827). In C. Mengozzi (Ed.), *Outside the Anthropological Machine* (pp. 27–26). Routledge.

Berger, D. L. (2021). *Indian and Intercultural Philosophy: Personhood, Consciousness, and Causality*. Bloomsbury.

Boteva-Richter, B., Dhoulb, S., & Garrison, J. (Eds.). (2021). *Political Philosophy from an Intercultural Perspective: Power Relations in a Global World*. Routledge.

Braidotti, R. (2013). *The Posthuman*. Wiley.

Canetti, E. (1989). *The Secret Heart of the Clock*. Farrar Straus Giroux.

Carroll, L. (1865). *Alice's Adventures in Wonderland*. Macmillan.

Cho, J. (2021). *Intercultural Communication in Interpreting: Power and Choices*. Routledge.

Dervin, F., & Yuan, M. (2022). *Reflecting on and with the 'More-than-Human' in Education: Things for Interculturality*. Springer.

Descola, P. (2014). *Beyond Nature and Culture*. Chicago University Press.

Ding, T. (2021). 丁天缺诗词集 *(A Collection of Ding Tianque's Poems)*. ICI LABAS.

Dreamson, N. (2016). *Reinventing Intercultural Education: A Metaphysical Manifest for Rethinking Cultural Diversity*. Routledge.

Drolma, W., & Robison, B. (Eds.). (2021). *The Other Face: Experiencing the Mask*. Bloss Plot Press.

Dübgen, S., & Skupien, S. (2018). *Paulin Hountondji: African Philosophy as Critical Universalism*. Palgrave.

etymonline.com. (2022). Nature. https://www.etymonline.com/word/nature#etymonline_v_2321

Foucault, M. (1991). *The Foucault Reader*. Penguin.

Foucault, M. (1994). *The Order of Things: An Archaeology of the Human Sciences*. Vintage.

Graneß, A., Etieyibo, E., & Gmainer-Pranzl, F. (Eds.). (2022). *African Philosophy in an Intercultural Perspective*. J.B. Metzler.

Haaz, I., & Ekué, A. (2022). *Walking with the Earth: Intercultural Perspectives on Ethics of Ecological Caring.* Globethics.net.

Hashas, M. (2017). *Intercultural Geopoetics in Kenneth White's Open World.* Cambridge Scholars.

Hershock, P. D., & Ames, R. T. (Eds.). (2022). *Philosophies of Place: An Intercultural Conversation.* University of Hawaii Press.

Hesse, H. (2022). *Trees: An Anthology of Writings and Paintings.* Kales Press.

hooks, b. (2009). *Belonging: A Culture of Place.* Routledge.

Ip, K. T. (Ed.). (2009). *Environment Ethics: Intercultural Perspectives.* Rodopi.

Janer, Z. (2022). *The Coloniality of Modern Taste: A Critique of Gastronomic Thought.* Routledge.

Lau, K.-Y. (2017). *Phenomenology and Intercultural Understanding: Toward a New Cultural Flesh.* Springer.

Lavanchy, A., Gajardo, A., & Dervin, F. (Eds.). (2011). *Politics of Interculturality.* Cambridge Scholars.

Leuthold, S. (2010). *Cross-cultural Issues in Art.* Routledge.

Ma, L., & van Brakel, J. (2017). *Fundamentals of Comparative and Intercultural Philosophy.* State University of New York Press.

Maffesoli, M. (1997). *The Time of the Tribes.* Sage.

Mengozzi, C. (Ed.). (2021). *Outside the Anthropological Machine.* Routledge.

Milstein, T., & Castro-Sotomayor, J. (Eds.). (2022). *Routledge Handbook of Ecocultural Identity.* Routledge.

Mukuni, J., & Tlou, J. (2021). *Understanding Ubuntu for Enhancing Intercultural Communications.* IGI Global Publishers.

R'boul, H. (2022). Postcolonial Interventions in Intercultural Communication Knowledge: Meta-intercultural Ontologies, Decolonial Knowledges and Epistemological Polylogue. *Journal of International and Intercultural Communication, 15*(1), 75–93.

R'boul, H., & Dervin, F. (2023). *Intercultural Communication Education and Research: Reenvisioning Fundamental Notions.* Routledge.

Reyes-Galindo, L., & Ribeiro Duarte, T. (Eds.). (2017). *Intercultural Communication and Science and Technology Studies.* Palgrave Macmillan.

Schepen, R. (2022). *Kimmerle's Intercultural Philosophy and Beyond.* Routledge.

Schweidler, W., & Klose, J. (2020). *The Gift and the Common Good: An Intercultural Perspective.* Academia Verlag.

Shani, D. (2018). *Kautilya and Non-Western IR Theory.* Palgrave.

Shklovsky, V. (1990). *Theory of Prose.* Dalkey Archive Press.

Spivak, G. (2002). Ethics and politics in Tagore, Coetzee, and certain sciences of teaching. *Diacritics, 32*(3/4), 17–31.

Tian, B. (2020). *Asymmetries in the Distribution of Power in the Multicultural Workplace: Reducing the Imbalances with Intercultural Competence.* Xī Shuǐ Shè.

van Binsbergen, W. (2021). *Intercultural Encounters: African and Anthropological Lessons Towards a Philosophy of Interculturality.* Lit Verlag.

van den Braembussche, A., Kimmerle, H., & Note, N. (Eds.). (2010). *Intercultural Aesthetics: A Worldview Perspective.* Springer.

van den Oever, A. M. A. (2010). Ostranenie, 'The Montage of Attractions' and Early Cinema's 'Properly Irreducible 'Alien' Quality'. In A. van den Oever (Ed.), *Ostrannenie. On 'Strangeness' and the Moving Image: The History, Reception, and Relevance of a Concept* (pp. 33–58). Amsterdam University Press.

Williams, L., Roberts, R., & McIntosh, A. (Eds.). (2012). *Radical Human Ecology: Intercultural and Indigenous Approaches.* Ashgate.

Yuan, M., Dervin, F., Sude, & Chen, N. (2022). *Change and Exchange in Global Education—Learning With Chinese Stories of Interculturality.* Palgrave Macmillan.

Zhuangzi. (2022). *Enjoyment in Untroubled Ease.* https://ctext.org/zhuangzi/enjoyment-in-untroubled-ease/ens?searchu=gourd&searchmode=showall#result

Zwaal, N. (2008). *Narratives for Nature: Storytelling as a Vehicle for Improving the Intercultural Dialogue on Environmental Conservation in Cameroon.* VDM Verlag Dr. Müller.

'Shut Your Eyes and See' (Joyce)

Abstract The conclusion summarizes what to take away from the entire book, emphasizing what art could do for preparing people to reflect on interculturality in in-/formal contexts of encounters. The concepts and notions covered in the book, that is, *identity, otherness, becoming, beliefs, ideologies* and *reflexivity*, are reviewed and problematized as a whole for art and interculturality. A framework concerning the role that art can play for interculturality in education is proposed to summarize the transformative power of art for the notion. Finally, the conclusion suggests that more can easily be done to systematize the inclusion of art in intercultural communication education.

Keywords Beyond dogmas • Power of art • Ideas • Uneasiness • Togetherness

Our book asked a lot of questions about interculturality but refused to offer systematic answers—letting you, the reader, decide for yourselves and, more importantly, continue exploring the complexities of interculturality through some examples from visual art.

In the current era of generalized conflicts, crises and deepening of unbalanced power relations, interculturality needs to be treated critically

F. Dervin, X. Tian, *Critical and Reflective Intercultural Communication Education*, https://doi.org/10.1007/978-3-031-40780-2_5

and reflexively. *Critical* refers here to the need to unsettle the 'obvious', our own critiques addressed to the notion and to interrogate systematically the way we speak about interculturality.

The poet Francis Ponge (1972: 81) warns us against 'ideas' in what follows:

> It may well be that I am not very intelligent; in any case ideas are not my forte. I have always been disappointed by them. The most well-founded opinions, the most harmonious (best constructed) philosophic systems have always seemed to me utterly precarious, caused in me a certain queasiness, an uneasiness, an unpleasant feeling of instability.

Isn't it how we feel sometimes in front of certain systems of thought that force us to think about interculturality in ways that are 'foreign' to our/others' own life experiences? Isn't it how we feel when we try to duplicate certain ideas about interculturality and paste them onto our and others' realities? Wouldn't it be for scholars how our research participants and/or students feel if they realized that the way we talk about their experiences through certain systems of thought often lead to them being judged for something they haven't (really) done?

A certain queasiness, an uneasiness, an unpleasant feeling. [Such feelings are central in intercultural work. However, they should shake us when they have to do with the mistreatment of others in research and education.]

For the writer Nabokov (2019: 25) art is 'a permanent wonder, a wizard with a trick of putting two and two together and making five, or a million'. One could easily say the same about interculturality. We experience together; we balance its *inter-* in *-ity*. What we get out of these constant movements is unpredictable, changeable, unstoppable, long term and short term. There is no straight line to interculturality. Finally, who can decide what 'our' interculturality should be and entail is a serious issue to reconsider. [Our 'answer': *No one. Give us the freedom to experience interculturality as we wish, but together with others*]. Interculturality is also a wizard to paraphrase Nabukov.

For the artist René Magritte (quoted in Domanski, 2011: 56) 'The mind loves the unknown. It loves images whose meaning is unknown since the meaning of the mind itself is unknown'. In a similar vein, interculturality *always* leads us into the unknown, the mysterious, against which we try to 'fight' back having been used to rationalizing everything—even when we pretend to be non-essentialist, non-culturalist and

non-stereotypical (which are themselves forms of rationality). In most cases, however, we lose since the unknown is the basis of who we are and what we do as social and intercultural beings. Art can teach us to love, accept and worship the unknown, its discontinuities, its somewhat aggressive contradictions and its impulsiveness, while trying to make us unthink and rethink our own becoming (together).

What the book suggests is *not* that we don't know anything about interculturality. Although a lifetime would never suffice to know *enough* about the notion, there is in fact a lot of (present, past, future, multilingual, ideologically diverse and divided) knowledge about interculturality all around. The problem is that our knowledge is often too limited and 'calcified'; our ideas are too 'precarious' (to borrow a word from Ponge).

[Ouaknin (2008) refers to the Yiddish word *Droshé genshenk* to hint at words that are often given to us as 'presents' so we can look at our realities differently. Thinking of never knowing enough about interculturality, we are reminded of a pair of French words *une demeure* and *un demeuré*. The former means *a mansion, a residence (a 'house')*, while the latter is *a fool, someone who is 'backward'*. This *Droshé genshenk* reminds us of the tension between 'being/staying home' and 'lacking in judgment'.]

Ideas about interculturality must thus be considered through different lenses to avoid 'calcification':

1. *The Korean idea of* 정 *(jeong)* refers to the impact we have on each other and to the kind of 'invisible residue' that we transfer to each other when we interact. Applying a jeong lens to interculturality can support decalcification of ideas—towards *the inter-*. Observe the 'residue' instead of erasing it.
2. *Contradictions*: I think I know something, but I must consider it through the lens of *opposites* to make it valuable knowledge for interculturality.
3. *Disappointment*: Allow ourselves to be disappointed by our systems of thought, by the ideologies that order us to think and act in specific ways interculturally.
4. *Mixed feelings*: I don't have to be overly enthusiastic about a given idea. Accept and reflect on emotions. *Enthusiasm as an enemy of interculturality.*
5. *Within and beyond the limit of words* (language is treacherous; language limits my worlds).

With this book, we have argued that art can help us work through these 'principles'. Art can go beyond the limit of words. Art can ask us to think in images beyond, for example, the 26 letters of the English language (Nabokov, 2019). Art can also modify our language and the way we use language. For Georgia O'Keeffe (in Hopkins Reilly, 2009: 379), 'I found I could say things with color and shapes that I couldn't say any other way... things I had no words for'. Art can allow us to 'escape' from the limits of our minds and feelings while 'learning to unlearn' (see Auden in Firchow, 2022: 134).

The chapters of this book have allowed us to reconsider interculturality through three main topics, moving from ideas that have often been discussed in the literature (e.g. Chaps. 2 and 3) to more pressing issues (Chap. 4): 'Reflecting on Identity Metamorphoses', '(Re-)encountering' and 'Rethinking How We Meet Interculturally'. Art was with us in the different chapters, offering support to reflect on, think further, unthink and rethink these topics.

Chapter 2 focused on issues of identity and especially how the 'crisis of belonging' (Bauman, 2004: 20) is urging us all to reflect on, question and critique identity. The importance of reflecting on issues of power was then introduced in relation to interculturality, declining each components of the triad composing *inter-cultur-ality*. The Chinese thought of Zhongyong (中庸, zhōng yōng) was used to support us in reflecting on the complex 'seesawing' processes that we experience, for example, living, working and studying with each other. Self-awareness, listening carefully and harmony in diversity were spelt out as (temporary) working principles. Zhongyong reminded us of the necessity to balance, recalibrate and, thus, remind ourselves of our and others' power statuses and struggles. Observing, discussing, deconstructing and working upon identity metamorphoses in interculturality *together with others* become vital lifelong necessities. The mirror of art is invaluable here. Chapter 3 took us through a certain number of concepts and images (e.g. face, mask) to problematize *encounters* or, to be more precise, the fact that we always (re-)encounter self and others. The art pieces from this chapter focused on what we called *mis-encounters* to urge us to think beyond too 'rosy' images of interculturality. Chapter 4 pushed us to become aware of the 'centrisms' that affect our understanding and discoursing of interculturality (e.g. adult-centrism, anthropo-centrism, lingua-centrism). In order to enrich our takes on the notion, we reviewed 'new' epistemic and ideological dimensions as discussed in different fields. These elements have just started to emerge in

the broad field of intercultural communication education. We argued that, by taking them into account, we might be able to expand our thinking and even our experiences of interculturality beyond 'our' centrisms. Arguments reviewed in the chapter included taking into account (1) the post-/decolonial, (2) intercultural philosophy and (3) the 'more than human' and ecology (sometimes referred to as 'the posthuman'). Each of these elements was illustrated with art pieces, which can support us in trying to integrate them in our thinking and increasingly in our future intercultural encounters.

This book is only a snapshot of what art could do for us to reflect further on interculturality. Many other (economic-political-ideological) questions concerning interculturality could also be put to us through art: *Who do we (wish to) become alone and together with others? What do we believe in interculturally speaking? What are we made to believe in together with others? How could we experience afresh and re-imagine the world alone and together?* Many scholars, educators and decision-makers have offered (often too precise) answers to these questions. *These questions do matter.* However, the answers must be carefully thought of not to reinforce our centrisms and, at the same time, exclude those who do not necessarily share our ideologies or who are not convinced by them. The constant back and forth of inter-cultur-ality should be a warning against closing any epistemic, educational (and ideological) door. The use of art can help us in keeping a balance between ideologies, imagination and co-creation. Canetti (2021: 60) reassures us here when he writes: 'Fear not your treasures turning to dust. They will decay only if you stand watch over them. Go ahead, quivering and uncertain. What you don't know will preserve what you do'.

You are about to close this book soon. We hope that it gave you the will to read more about interculturality and many of the topics that it covered and to look at art for inspiration, criticality and renewed reflection. Looking at the current state of our worlds, we have no choice. *We must persist and transform together.*

REFERENCES

Bauman, Z. (2004). *Identity*. Polity.
Canetti, E. (2021). *Notes from Hampstead*. Macmillan.
Domanski, D. (2011). *Earthly Pages*. Wilfrid Laurier University Press.

Firchow, P. E. (2022). *W. H. Auden: Contexts for Poetry*. University of Delaware Press.

Hopkins Reilly, N. (2009). *Georgia O'Keeffe, A Private Friendship, Part II*. Sunstone Press.

Nabokov, V. (2019). *Think, Write, Speak*. Penguin.

Ouaknin, M.-A. (2008). *Zeugma. Mémoire biblique et déluges*. Le Seuil.

Ponge, F. (1972). *The Voice of Things*. McGraw-Hill Book Company.

INDEX[1]

[1] Note: Page numbers followed by 'n' refer to notes.

© The Author(s), under exclusive license to Springer Nature
Switzerland AG 2023
F. Dervin, X. Tian, *Critical and Reflective Intercultural
Communication Education*,
https://doi.org/10.1007/978-3-031-40780-2

Printed by Printforce, the Netherlands